The Paintings of
George
Bellows

The Paintings of
George
Bellows

BY MAHONRI SHARP YOUNG

WATSON-GUPTILL PUBLICATIONS, NEW YORK

First published 1973 in New York by Watson-Guptill Publications,
a division of Billboard Publications, Inc.,
One Astor Plaza, New York, N.Y.

Manufactured in Japan

Library of Congress Cataloging in Publication Data
Young, Mahonri Sharp, 1911–
　　The paintings of George Bellows.
　　Bibliography: p.
　　1. Bellows, George Wesley, 1882–1925. 2. Realism
in art. I. Bellows, George Wesley, 1882–1925.
II. Title.
ND237.B45Y67　　　759.13　　　73-5695
ISBN O-8230-3885-8

First Printing, 1973

Anybody who is concerned with George Bellows depends on Gordon Allison. He and his father and their firm of H. V. Allison and Son have represented the Bellows estate for years, and over the years they have done the best job that has ever been done in building up and sustaining the work of an American artist. Gordon Allison knows everything there is to know about every Bellows painting, and he is courtesy and patience itself in answering curious questions and frantic queries. For him, Bellows is a way of life. He is the source of most of what there is to know about Bellows today.

It was a pleasure to work with Charles H. Morgan when he was writing his indispensable biography of Bellows, which is the only important printed source for material on the painter. While this book was in progress, the collection of Bellows paintings belonging to C. Ruxton Love came on the market. Norman Hirschl, of Hirschl and Adler, who handled the dispersal of the collection, has been a pleasure to deal with, as always.

I would like to thank Donald Holden, Editorial Director of Watson-Guptill, who suggested doing a book on Bellows, and Jennifer Place, who stood by me through the editing. My secretary, Carolyn Newpoff, has been a tower of strength.

I would also like to thank the museums and private collectors who made their paintings available for reproduction.

It has been a great pleasure to be in charge of the Bellows Collection of The Columbus Gallery of Fine Arts, by far the most important in the country, and to watch it grow.

Mahonri Sharp Young

1882 Born 265 East Rich Street, Columbus, Ohio, August 12. Parents came from Sag Harbor, Long Island. Attended Sullivant School and Central High.

1901 Entered The Ohio State University, where he played baseball and made drawings for college publications. Left at start of senior year.

1904 Studied under Robert Henri, his "father in art," at the New York School of Art at the corner of Sixth Avenue and 57th Street.

1906 Rented a studio in the Lincoln Arcade Building at 1947 Broadway, which he kept until his marriage.

1909 Taught at the Art Students League. Married Emma Story, honeymooned at Montauk, Long Island, and bought the house at 146 East Nineteenth Street, on "The Block Beautiful," where he lived until his death.

1911 Visited Monhegan Island in Maine, and spent the summers of 1913 and 1914 there. Birth of daughter Anne.

1913 Exhibited in Armory Show. Elected a full member of the National Academy.

1915 Birth of daughter Jean.

1916 Started making lithographs. Spent summer at Camden, Maine.

1917 Spent summer in the artist colony of Carmel in California.

1918–19 Spent the summer at Middletown, near Newport, Rhode Island.

1919 Taught at the Art Institute of Chicago.

1920 Rented a house at Woodstock, New York.

1921 Bought a home and studio in Woodstock.

1925 Died of appendicitis in New York, January 8. Memorial Exhibition at the Metropolitan Museum of Art.

Art Institute of Chicago, "George Bellows: Paintings, Drawings and Prints," Chicago, 1946

Art Students League of Columbus, "A Catalogue of Paintings by George Bellows," Columbus, 1912

Bellows, Emma, *The Paintings of George Bellows,* New York, 1929

Bellows, Emma, and Beer, Thomas, *George W. Bellows: His Lithographs,* New York and London, 1927

Bellows, George, "The Big Idea: George Bellows Talks About Patriotism for Beauty," *Touchstone,* 1917, v. 1, pp. 269-275

"Bellows in Chicago," *Arts and Decoration,* 1919, v. XII, p. 10

Bolander, Karl, "The George Bellows Exhibition," *Bulletin of the Columbus Gallery of Fine Arts,* 1931, v. 1, p. 15

Boswell, Peyton, Jr., *George Bellows,* New York, (n.d.)

Braider, Donald, *George Bellows and the Ashcan School of Painting,* New York, 1971

Buchanan, Charles L., "George Bellows: Painter of Democracy," *Arts and Decoration,* 1914, v. 4, pp. 370-373

The Columbus Gallery of Fine Arts, "Paintings by George Bellows," 1957

Ely, Catherine Beach, "The Modern Tendency in Henri, Sloan and Bellows," *Art in America,* 1922, v. 10, pp. 132-143

Flint, Ralph, "Bellows and His Art," *International Studio,* 1925, v. 81, pp. 79-88

Gallery of Fine Arts and Art Association of Columbus, "Exhibition of Paintings by George Bellows," Columbus, 1918

Gallery of Modern Art, "George Bellows: Paintings, Drawings, Lithographs," New York, 1966

Hirschl and Adler Galleries, "George Bellows," New York, 1971

McIntyre, Robert G., "George Bellows: An Appreciation," *Art and Progress,* 1912, v. 3, pp. 679-682

Metropolitan Museum of Art, "Memorial Exhibition of the Work of George Bellows," New York, 1925

Milch Galleries, "Exhibition of Paintings by George Bellows," New York, 1918

Morgan, Charles, *George Bellows, Painter of America,* New York, 1965

National Gallery of Art, "George Bellows: A Retrospective Exhibition," Washington, 1957

An Ohio State Alumnus, "Bellows Re-Appreciated," *Ohio State University Monthly,* Columbus, March 15, 1957

Trapp, Frank, "George Wesley Bellows," Amherst, Massachusetts, 1972

Young, Mahonri Sharp, "George Bellows," Ohio State Fair, Columbus, Ohio, 1967

Young, Mahonri Sharp, "George Bellows: Master of the Prize Fight," *Apollo Magazine,* February, 1969, v. LXXXIX, no. 84, pp. 162-166

George Bellows was the fair-haired boy of American art. In his forty-two years, he painted an amazing number of good pictures. He had success when he was young, the time success is most needed. Nothing bad happened to him except his early death, and that was so unexpected he never gave it a thought. He never saw the Depression or the style change to abstraction, and the worst thing in his life was World War I, which was the Great Crusade. It never occurred to him that life was not real; he saw the same world as the other fellow, full of sun and sea, children on the porch, and tennis on the lawn.

Bellows was an American realist in the days when the woods were full of them. It was not a bad way of looking at life—accepting the good along with the evil. Realism faced the moonlight on the Hudson as squarely as the slums. Bellows couldn't walk down the street without seeing forty-two subjects to paint. He didn't have much time to sketch; he painted direct, or from memory. He had no trouble with composition; he *saw* things in groups.

Subjects were all around him, from lobster boats to houses. He never ran out; he never even scratched the surface. Bellows just opened his eyes. He painted everything he saw, easily and naturally, and he died with his subject matter barely touched. It does seem a waste, when he was going strong.

His pictures have lasted well, in both senses. Considering that he had some pretty high-flown ideas about technique, it's remarkable how sound the paintings are; when cleaned up, they're in great shape, very much the way he painted them. He didn't repaint much, so the paint is fairly thin, but it's remarkable how fresh they are; he's lasted better than Luks, for instance, or Henri. You see his paintings today as he saw them. He was not a premeditative painter and what he intended was what he painted; there wasn't that much distance between the brain and the brush. We see what was there at the time, which is remarkable, considering that he died almost fifty years ago.

We like to think that the realist vision is a fantasy, but it's solid rock compared to some of our obsessions. It has a wide appeal because it's widely shared; most people see that way today. Besides, there's something immensely attractive about Bellows' outlook, something which is still present in the world we deplore. We try not to find things fascinating or colorful, but they are.

He painted outdoors in the summer, the pale artist plying his sickly trade; in the winter he worked in the studio, with the clear north light and the wonderful smell of turpentine. The studio is sacred ground: the kids can't go in and the wife can't tidy up. Occasionally, in the late afternoon, an old friend would drop by, maybe Henri, and they'd sit there staring at the canvas on the easel. It isn't easy to say anything to an artist: if the lower right-hand corner is not quite perfect, there's obviously no easy way to fix it or the artist would have already taken care of it. But if things were going great, Henri would see it at once and could be the most generous man in the world. Artists really believe that critics don't know what they're talking about. Of course, they're glad to get good reviews from Huneker or McBride, but good reviews are not really the name of the game.

Bellows was one of those happy men who find their romance in reality, which he vastly preferred to dreams. A man of no particular imagination, he found life more entrancing than he could possibly imagine. It continually surprised him with its wonder and its beauty. Everything was better than he expected. Women were more wonderful; his own daughters were more delightful. Early afternoon at Matinicus, and morning in the Catskills—with the long broken shadows of the heavy trees on the grass—never failed to delight him. He never had time to paint flowers, like his friend Speicher; it was life he was after. He couldn't paint all of it, but he gave it a good try. He probably wondered what all the fuss made over art was about. Bellows was as close as you can get to being a natural painter. There was no indecision, he just went right at it.

Bellows took care of the quantity and let the quality take care of itself, which it did, to a very large extent. He painted very few bad pictures, while we treasure disasters by Cézanne. Bellows was not a stern critic of his own work; he thought it was fine. What's the good of saying you're worse than you are? Leave that to other people. Maybe it's not the greatest in the world, but compared to the fellow next door, it's pretty good, which is all you have to worry about.

He did not repeat himself endlessly in subject matter, like Ernest Lawson or Prendergast, or even Henri. He could do anything anybody else could do, and maybe better. He kept almost everything he painted, and rarely touched it again. Many of the summer landscapes were painted that day, or that morning. He was a fast worker, and he enjoyed knocking them out. When he finished the picture, he quit, and if he did not feel like painting he loafed or played with the kids. When he got a little restless, that was a sign he was ready to go back to work. If most artists worked as much as they talked, they'd

George Bellows, *photograph courtesy of H. V. Allison & Co., New York, New York.*

turn out a lot more pictures.

Bellows was made for success. We like to think it's bad for people, but it didn't make any difference to him, it just meant he could buy the house in Woodstock. Success made him more sure of himself and allowed him to do his own work. He didn't have to chase portrait commissions, which he wasn't very good at anyway. We exaggerate the benefits of failure; Bellows found success exhilarating, as most people do.

An independent character, he was a big man with a head as bald as a bullet, and people didn't impose on him very much. He didn't have many doubts about himself or about his work. Things went well with him, and why not? He never had too much to worry about, and he was not exactly given to intro-spection. He loved life, and that's what people got from his pictures. They made a hit in those days, and they do now. He was the kind of man people are glad to see. He made them feel good, and so do his pictures. There isn't much mystery about Bellows, or about his work. He was what he seemed, and he believed that things are what they seem; it's not a bad way and it may very well be true.

George Bellows' parents came from Sag Harbor, down on the end of Long Island, which was one of the great whaling ports. When gold was discovered in California in '49 the whole male population moved out there and the place has never been the same since. Bellows' father, who came to Ohio in 1850 by canal boat, was known as "Honest John," not a bad name for a contractor, and he built the Franklin County Courthouse after he moved to Columbus. It was not very beautiful but it was built a lot better than Boss Tweed's courthouse in New York. "Honest John" always felt that George should have followed his trade.

He was fifty-two when his son was born, and they were never very close. They lived on Rich Street, and if you want to know what Columbus was like in those days, read Thurber, for he and Bellows were near enough of an age. The houses they knew are still there, but they have gone down in the world and now have a peculiar desolation.

George Bellows had the great American boyhood, and there's a lot of it in his paintings. Americans like his work because they can see where they came from; Europeans have never heard of it. It's small town life, though Columbus was never that small, and it still goes on for many people.

The real love of his youth was baseball, in the days when baseball was the national sport. He was a hero in the neighborhood, and he's still spoken of

around Columbus as a great baseball player. He seriously considered turning professional, which would have been the end of him as a painter. Walt Kuhn, who was a trick bicycle rider at county fairs in his youth, never got away from the bareback riders and the clowns. Bellows painted a lot of sports but not a single baseball picture, perhaps because the game is too spread out, except for the group at the plate. No artist has done much with baseball, with the crowd, the afternoon sun, and the score-cards, though it's still part of American life.

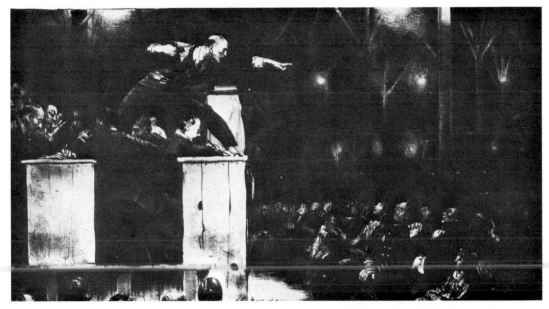

Billy Sunday, *1923, lithograph, 8⁵⁄₁₆" x 16¼". Collection of the Columbus Gallery of Fine Arts, Columbus, Ohio.*

Bellows was brought up on the Near East Side of Columbus, then the best part of town, but you don't exactly wander around there anymore. In those days it was a haven of tranquility, with a double row of elms the length of Broad Street and a lawn down the middle. This is the world Dreiser wrote about. It was hard to tell whether you were in Vincennes or Columbus; the banks of the Wabash are very much like the banks of the Scioto. Then, as now, there was another, darker Columbus, with whorehouses on Front Street, but it never made the slightest impression on Bellows. He played baseball all Saturday and on Sunday he made ice cream on the back porch. It was not a bad life for a boy.

Bellows never got along with his old man, which was perfectly normal in those days. What does a man in his sixties have to say to a teenage boy? They just stayed out of each other's way. The old man didn't approve of his son's painting any more than he did of his baseball: he thought that both were use-less. George never showed the slightest desire to become a contractor, which was a shame, for his

father had a good business: plenty of Columbus businesses are a hundred years old and going strong. Not that George cared what his father thought; "his point of view, his character even, belonged to so remote a past that I look upon many of his ideas to this day with amazement and sorrow."

George did what he wanted, his mother saw to that. He was a great "Hey Ma!" boy, and he kidded her a lot. He was a good son. He got along with her just fine, the way he did with everybody else, and it shows in the portraits he did of her, which

Shower Bath, *lithograph, 22" x 31⅞".*
Collection of H. V. Allison & Co., New York, New York.

show a strong-minded and what in those days was considered a comfortably stout woman. George married a strong-minded woman too, and it's fair to say that she was never close to her mother-in-law. His wife did not always come along on George's visits to Columbus; she had plenty of family of her own. If George wanted to go back to see his mother that was all right with her, just as long as she did not have to go.

When Bellows went to Ohio State University, it really was a college in a cornfield, and it had fewer students in those days than it has faculty now. Everybody knew everybody, and sports were everything, which they still are. Because of his baseball, Bellows made Beta, the greatest thing in a man's life; there are still men who feel that way, but they're no longer on campus. He seemed the per-

fect college man to other artists in New York, but he was too much the artist to be satisfied at the university. He became the leading cartoonist for the college yearbook, and to this day the walls of the living room of the Beta house are lined with Bellows drawings of football heroes and prom queens with shirt waists. Outside, Fraternity Row is crowded with couples in spring. The sycamores around the pond on the Oval have grown huge, and the clothes are different, but that's about all. In the spring, Columbus is covered with blossoms to a depth unknown in the East. You can smell them for miles

Bellows was lucky enough to find one great teacher in college, Joe Taylor, who taught him to read, but he quit without taking his degree and went to New York to study art. George Sand may have wanted her son to be a painter, but old Mr. Bellows did not feel that way and neither do most people. Mrs. Bellows wanted her boy to do whatever he wanted, and she won. This was the real break in Bellows' life. From the time he walked into Henri's class in New York he was made.

He may have said he hated New York, most people do sooner or later, but he took care not to leave it for long. Many of his friends in New York were Ohioans, like Ted Ireland. Nobody seems to remember Ted Ireland around Columbus, yet he was one of George's closest friends. At the League they said he could paint better than Bellows, though that's hard to believe. He was so skillful that he could turn out commercial work with his left hand, and if you can do that pretty soon you're turning it out with your right.

When he went to New York, Bellows shared a studio in the Lincoln Arcade, a magnificent rabbit warren on upper Broadway. Henri taught his classes there, loping out front, giving a criticism, telling you to be yourself, talking about everything under the sun, sheer magic really. There were sculptors too, Prince Paul Troubetskoy and Sherry Fry and one pandemonium of a machine shop where visiting small boys were given solemn rides on a motorcycle around the floor, between the windows and the lathes, which clanked away in a glorious mist of oil, hot metal, and cigars.

All the crowd dropped in, and there was always room for more on the floor. When they ran out of blankets, they used *The World* or *The Sun,* which made a funny noise when you turned over. Bellows loved being surrounded by people and Ted Ireland knew everybody, including Eugene O'Neill, whose actor father tried to keep him in New Bedford, far from the gin mills, with complete lack of

success. O'Neill, a long-time friend of Ireland's, had a real affinity for getting into trouble, and the boys were always trying to marry him off to some good woman. Some of Bellows' friends drank a lot, what with a saloon on every corner, but Bellows was a cheese and cracker man. While O'Neill tried to sell cheap jewelry, Bellows played baseball to make money and to get out in the open air.

The city was a revelation to him. He'd been brought up in a small town, with the heavy trees, the painted houses, the lawns mowed by grim boys, an America which has retreated to the villages and the suburbs; you won't find it in downtown Columbus, for even Middle Western cities have been blasted by blight. New York was a revelation.

There's still plenty of life in the teeming New York streets, but it's no longer healthy for boys from the Middle West. In those days, unless the whores or the whiskey got you, you were perfectly safe. Why, Eugene Myers, an early friend of Bellows, walked the streets at night well into the Thirties, getting up at three in the morning, wearing carpet slippers with no backs. They got something mystic from night and the city, and Bellows had this religion too. He got the doctrine from Henri, who preached it all his life, but he could have gotten it anywhere.

It's remarkable what he saw; most people don't see a damned thing. Dreiser puts it very well in *The Genius:* "As it was, the great fresh squares such as Washington, Union and Madison, the great streets, such as Broadway, Fifth Avenue and Sixth Avenue, the great spectacles, such as the Bowery at night, the East River, the waterfront, the Battery, all fascinated him with an unchanging glamour." The first part of Dreiser's novel covers Bellows' world in the Middle West and in New York.

Soon after he came to New York Bellows was engaged to a very proper girl, the kind they wanted O'Neill to marry. She was a student of the New York School of Art, which was Chase's until Henri took it away from him. Chase particularly appealed to the ladies, and rowdyism was not exactly in order on the female side of the doors that separated the sexes. Our mothers were a pretty formidable bunch, particularly if they were interested in the arts: they were nothing if not high-minded. Emma Story qualified. She was from Montclair, New Jersey, a pleasant suburb north of Newark, George Inness' town, but for Emma it was a great height from which she could look down on George Bellows and Columbus, Ohio.

They did not fall in love at first sight. She was more drawn to Edward Hopper, and she liked Rockwell Kent, who gave her a lecture on St. Gaudens' statue of Sherman in the Plaza, and whose later career was partly financed by the Columbus collector, Ferdinand Howald, who never bought a Bellows. Theirs was a long courtship and the course of true love did not always run smooth. "Please see that your hands and fingers are immaculate because if you sit next to me at the table I do not want my appetite taken away looking at them." She was a powerful woman, and, as Charles Morgan points out in his excellent biography, after George's death she managed to give the impression of being taller than she was. Emma got her Christian Science from her mother, and while she did not practice law like her sister, she certainly laid it down. George was high-spirited, even raucous, what Columbus would admiringly call aggressive; Emma thought he should be toned down. Since they both had tempers, they fought. He worshiped her, and that was the way she would have it.

This went on for five years, like something out of Trollope. Needless to say, Emma was not going to live in the Lincoln Arcade. Finally George's father put up $10,000 for the house on Nineteenth Street—maybe he was not so bad after all—in the Block Beautiful, between Irving Place and Third. The house and block are still there, and you'd have to be a very successful artist to live there.

Bellows worked on the house for months before they were married, making shelves and cabinets when he should have been painting. The young couple spent their honeymoon at Montauk and stopped off at Sag Harbor on the way back to see George's relatives, who had not been invited to the wedding. They had to stop since George had to borrow trainfare back to the city. It would be good to say that old Bellows passed along his love of the sea, but there's nothing to show that he had any love for it. The young couple must not have been particularly taken with Long Island, since they never went back, preferring other beaches. Yet the place has a charm of its own, with potato fields to the horizon; maybe they reminded George too much of the flat country west of Columbus.

During these early years, Bellows was a great New York painter. The Ashcan School is the artistic equivalent of the settlement house movement: the drive to the slums, which made you feel so good if you did not have to live there. We are seeing the end of this, now that the poor won't have us. But it was not just the harsh poetry of the slums that attracted him. He painted hymns to Riverside Drive,

Old Billiard Player, *1921, lithograph, 9" x 7½". Collection of the Columbus Gallery of Fine Arts, Columbus, Ohio.*

Four Friends, *lithograph, 12" x 9". Collection of H. V. Allison & Co., New York, New York.*

Charles E. Albright, *pen and ink. Collection of the Columbus Gallery of Fine Arts, Columbus, Ohio.*

Study of Hands for Portrait of My Mother, *charcoal, 12" x 14". Collection of Benjamin Sonnerby.*

one of the most spectacular parts of town; there are still warships in the Hudson, but very few ocean liners.

To men from west of the Alleghenies, the water around New York is a perpetual astonishment. When my father came from Utah to study at the Art Students League, several years before Bellows, the first thing he did was to take the subway out to Coney Island to see the ocean. Compared to the Great Salt Lake, it's quite a sight. To someone like Bellows, whose idea of a river was the Scioto or the Olentangy, the Hudson is very impressive. New York is a curiously inward looking city considering that it is surrounded by waterways that rival San Francisco.

You could make an interesting tour of New York visiting the places Bellows painted. The light on the snow has not changed. The Aquarium has gone, but it was a wonderful place, with the sharks and giant sea turtles. Bellows is a much more original landscape painter than many who carry the label, and his point of view is often startlingly unexpected.

Bellows laughed easily and a lot, but there is very little humor in his painting. The lithographs, of which he made a great many, have much more wit and caustic bite. Containing some of his best work, they were extraordinarily popular during his lifetime and during the great roaring print boom that ended with the Crash. His rambunctious Hogarthian scenes are a lot more satisfactory than his occasional attempts at higher things, as his wife would have called them, while his war pieces are better not stressed.

Bellows had all the town boy's love for the country. He never had to milk cows or chase horses through the fields. The farmyard was a place of wonder and imagination; to the summer visitor who doesn't have to butcher them, even the hogs are jovial. Bellows' chickens are fun, his white horses, figures of romance. The country meant long summers with the family, a chance to get away from New York and the art world. Until they got their own place at Woodstock, they stayed with the farmer and ate tremendous meals of chicken fricassee and mashed potatoes and corn on the cob. He loved showing the country to his daughters. In those days, summer in New York was a holy terror; you sat in the window over the fire escape in your undershirt and drank cold ginger ale from the delicatessen downstairs. That was one great thing about being an artist—you didn't have to be in New York in the summer.

Summers gave Bellows new subject matter. Artists couldn't just paint out of their heads, the way they can now. There was not much to paint in the studio except portraits, nudes, flowers, and still life—pretty thin. Henri did all his painting in the summer and used the winter for teaching; Marin spent the winter fiddling around and talking to Stieglitz; Bellows was not that much of a talker, and besides he had too much energy. Winter was a good time to make lithographs. Light wasn't important, and Bellows loved to draw, in a big sprawling way. He loved snow in New York, and there was a lot of it in those days, with no cars to chew it up; the prize fights went on all winter, and there was skating in the Park.

About the only place he did not paint was Columbus, Ohio. Oh, he painted portraits there, of the local rich and the bigwigs at the University, and he did some lithographs of the state hospital, the YMCA pool, and going to church on Gay Street, but he never painted what was out the window, winter or summer. Probably it never occurred to him it was paintable; the old home town was not exactly romantic for him. He was loyal, but Columbus was the town that he had worked so hard to get away from. Other artists have painted it, like his Woodstock friend Charlie Rosen, who taught at the Columbus Art School, and Bob Chadeayne, who was in Bellows' class at the League. When you think what Columbus meant to Thurber, who wrote about nothing else, you see how little Bellows used it. It meant home and family, and what he had to get away from if he was going to amount to anything.

Aside from Columbus, he liked to paint most anything, except apples. Even his stiffest and most wooden figures have life, sometimes too much. These simplified fishermen with tube-like trousers lived on in Walt Kuhn and Rockwell Kent; they represented man against the sea and the dignity of labor.

Poverty shocked him, and the War. You didn't see many poor people at the corner of Broad and High in Columbus, while you couldn't avoid them in New York. We think we invented poverty, but they did it better in the old days. The color was different, but the quantity and the quality were really there. You could look the other way, like Henry James, but Bellows wanted to do something about it. He didn't want the poor to be always with us. Lots of other artists, including John Sloan, felt that way, but their socialism doesn't show much in their paintings; they kept it for *The Masses* magazine, where Sloan was art editor, and Bellows occasionally contributed.

The other thing that blackened his life was the

War. This was not a private obsession—it was as contagious as Spanish influenza. People like Stieglitz, Hartley and Huneker, who loved Germany, were immune, but they did not exactly talk against the War either, for that was not popular. Edith Cavell in Bellows' lithograph looks as though she were posed on the steps leading up to the balcony of the house on Nineteenth Street, and maybe she was. For that generation, the War was the end of the world, and there was no doubt that it was the Germans' fault. This was the most violent emotion of his life, and it had a bad effect on his art. His war pictures are the worst he ever painted. This was a real firestorm that swept over America; small boys prayed that the War would last long enough for them to get into it, and for some of them it did.

It's hard to believe how belligerent Americans were; Edith Wharton and Henry James went out of their minds, but at least they were living in Europe. Feeling against the Huns ran higher than it ever did against the Nazis. This was America's favorite war, though the soldiers in the brown camps may not have felt that way when they caught the flu. Many of Bellows' friends had studied in France, been brought up there, really, but he had no beret in his past, no French girl friends like Alfy Maurer, no blue blouse, no Gauloise hanging from his lip.

Bellows is one of the few American artists who did not study abroad. Eakins and Homer, most American of all, were soaked in Europe. Eakins went right through the whole course of sprouts at the Beaux-Arts, while Homer exhibited in Paris and spent summers at Scarborough on the North Sea, in Sitwell country. All The Eight except for Sloan were internal exiles who pined a bit for the "old country" of their student days, usually France. There was no reason why Bellows never went to Europe. New York was the closest he needed to get. Europe might have spoiled him. He would have painted fine pictures in France, for he painted fine pictures anywhere.

Bellows got going awfully fast. At the age most men were learning their trade, Bellows was winning prizes. Though he looked completely original, he painted the way he did because of Henri. His pictures were easily accepted by the juries, the critics, and the public. He never had to go through a long dry spell. He was an Associate of the National Academy before his twenty-seventh birthday, one of the youngest in history, and he was a full Academician at thirty. Some people say that Bellows was an illustrator. When he was turning out half-baked Charles Dana Gibsons, and the way he was going he would have been another Howard Chand-

Sunday Going to Church, 1921, lithograph, 12" x 15". Collection of the Columbus Gallery of Fine Arts, Columbus, Ohio.

Edith Cavell, 1918, lithograph, 25½" x 19⅝". Collection of the Columbus Gallery of Fine Arts, Columbus, Ohio.

Life Class, *lithograph, 19" x 25". Collection of H. V. Allison & Co., New York, New York.*

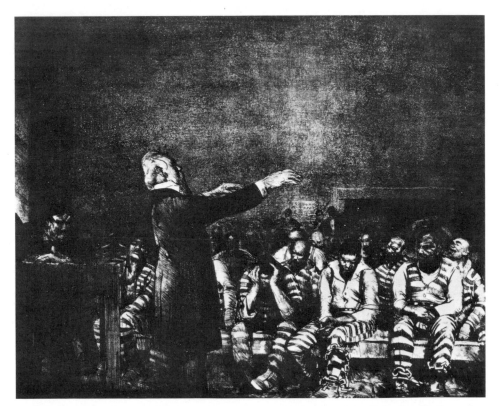

Benediction in Georgia, *1916, lithograph. 16⅛" x 20". Collection of the Columbus Gallery of Fine Arts, Columbus, Ohio.*

ler Christie. Lots of his friends started out as illustrators, like Glackens and Shinn. Without money from home, Bellows might very well have gone into illustration; he had the facility, if he had slicked up his style and prettied up his draughtsmanship. Illustrators like N. C. Wyeth and Abbey were tremendously successful and influential, but it hurt them as artists, and they knew it. Bellows painted as truthfully as he could; there's all the difference in the world.

Henri made a painter out of him, as he did out of many others. It might have happened without Henri, but he deserves the credit. Henri had more pupils than you could shake a stick at, but Bellows was the best. He painted better pictures than Henri, but Henri was seldom jealous. They were friends for life. Henri was proud of Bellows; he had cause.

Henri said that he didn't ask Bellows to be a member of The Eight because he was too young, and Jerome Myers because he was too old. This is not very clear; Henri was a complicated man who enjoyed making mysteries, like hiding from his friends when he got married. He probably didn't like Myers and found his work sentimental. Myers and Bellows would have fitted better than Davies, Prendergast, and Lawson. Perhaps Henri did not consider it wise to put on a pure Henri show: besides, those three had reputations and followings of their own. Later, Henri seemed to regret leaving Bellows out, but if Bellows cared, he never showed it.

Henri got him started, but his wife Emma kept him going. George was not exactly a weakling, and Emma tried to put him in his place. George Bellows thought he was just as good as the next man, maybe a little better, and it never occurred to him that he should be ashamed of himself. She treated him like an overgrown boy who needed some good woman to look after him, and in a way she won the upper hand.

Bellows had lots of artist friends, as you would expect. There was a certain amount of jealousy of his success, particularly from the older men. But you couldn't stay mad at Bellows, he was a very engaging guy. Besides, you had to admit his work was good. He stayed out of art politics pretty much and he did his share on juries and committees, but he did not try to run the Academy. He just wanted to paint.

Henri taught him that there was only one kind of art, and when Bellows ran into abstraction at the Armory Show, he was jolted. It's a whole new concept, and if one way is right, the other is wrong. The men who had studied in France knew what was

going on, but Bellows wasn't one to hang around Stieglitz' gallery at "291," which was about the only place in town where you could see the gathering storm. "291" was out of bounds so far as Henri's gang was concerned, and Bellows was the most loyal of the lot. Sloan knew Hartley, Glackens knew Dove, and they all knew Alfy Maurer, but Bellows didn't poke around much. He wasn't much interested in what other artists were doing, except his friends, who all painted very much the way he did. Bellows couldn't have put up with Stieglitz anyway; Stieglitz had an incredible need to dominate, and Bellows was not about to be dominated. Besides, Stieglitz never stopped talking.

The amazing thing is that the Armory Show was put on by Henri's friends and pupils. When Freud came to America he said "I am bringing you the plague." Walter Pach, Arthur B. Davies, and Walt Kuhn could have said the same when they came back from Europe with the pictures. As Davies said to Myers, "you will weep when you see what we've brought over."

George Bellows had five pictures in the show plus a batch of drawings. He was one of the twenty-five members of the Association of American Painters and Sculptors which organized the show and he was on the Reception and Publicity Committee. He may not have been in the inner circle, but he was in the next one. The whole idea was to give American artists a chance to show, but Bellows was not too pleased with what he saw. As he defensively argued with a reporter, "In my humble opinion the Cubists are merely laying bare a principle of construction which is contained within the great works of art which have gone before . . . they have arrived on the border land of possible technical discoveries which may or may not be new and which may or may not be valuable." In the end, he resigned from the Association in a huff, along with Henri, Mahonri Young, and Myers. He had mixed feelings about the whole thing, and well he might.

Bellows was very much interested in the craft of painting, and the Armory Show gave him a push. He was strongly and badly influenced by writers such as Denman Ross, who made a detailed study of sixty different sets of palettes. Some of the pictures Bellows painted under his influence were limited to a few colors, others were painted with almost the full spectrum. For many of his paintings he used colors recommended by Hardesty Maratta, another theorist of the time. It is difficult to exaggerate the colorfulness of an American autumn, and here the Maratta colors worked; at other times

the result is close to disaster. He listened to Jay Hambidge, John the Baptist of a doctrine called "Dynamic Symmetry" (*Elements of Dynamic Symmetry* and *Application of Dynamic Symmetry*), which Bellows regarded as "probably more valuable than the study of anatomy." Hambidge's influence was dominant until the end of his life. Maratta's colors and dynamic symmetry had a poor effect on Bellows' painting, as they did on Henri's and Sloan's. It didn't help Bellows when he started to think. Bellows was a very sensible man, but he wasn't sensible about theory.

Bellows was always successful; there was never any question about money. Oh, they weren't rich, just comfortable, with the house on Nineteenth Street and the house in Woodstock. Glackens lived like this, and so did Henri, who had money in safe deposit boxes all over town, but the rest of the artists did not, and Bellows was their rich friend. Bellows never gave it a thought; he sold to rich people, of course, but they didn't impress him. If he found Mrs. Whitney exhilarating he never latched onto her the way Luks and Davies did. He was nobody's little brother, and I doubt whether Emma would have put up with it anyway. He didn't have to push his pictures—they sold themselves. McBride said, "Business men and other citizens not especially instructed in the arts who happened to meet him were surprised and delighted to find they could know an artist on even terms." It is true: Bellows appealed to people who don't like art, as Wyeth does today. "It was something new in America, for at that period the general public still looked askance at artists, thinking them a race apart as in fact they mostly were. Even more satisfactory, when, emboldened to see the pictures by this he-man acquaintance, they found there was no nonsense in them either."

The great thing about being an artist was that you could go anywhere. He knocked about the country a fair amount, as far as California, and found it endlessly fascinating. Bellows fell in love with Maine. He loved the pines, the sea, the surf, and the rocks. There are no mosquitoes in his Maine and no fog. The coastline is incredibly varied compared to Franklin County. He loved Matinicus, which is now just about as remote as it was then. There is a boat three times a week, which brings over the mail and the groceries. Local residents still remember him. He didn't stick out the storms like Winslow Homer, or the icy winters like Rockwell Kent.

He spent time in Carmel and Santa Fe, but he ended up in Woodstock. In the summer, the Hudson

Portrait of John Carrol, *1921, Conté crayon, 11½" x 9¾". Collection of the Columbus Gallery of Fine Arts, Columbus, Ohio.*

My Family, No. 2, *1921, lithograph, 10⅛" x 8". Collection of the Columbus Gallery of Fine Arts, Columbus, Ohio.*

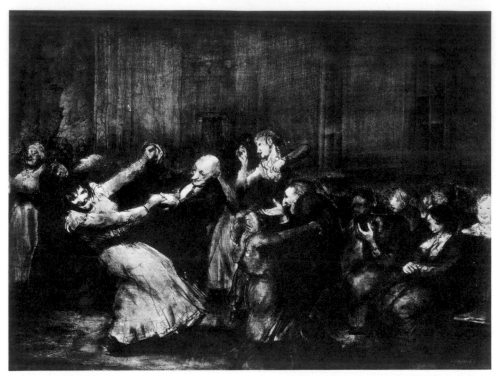

Dance in a Mad House, 1917, lithograph, 18½" x 24¾". Collection of the Columbus Gallery of Fine Arts, Columbus, Ohio.

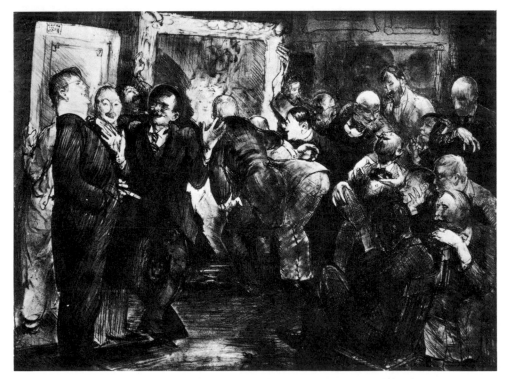

Artists Judging Works of Art, 1916, lithograph, 15" x 19½". Collection of the Columbus Gallery of Fine Arts, Columbus, Ohio.

Valley is beautiful, if you don't mind the heat; the rolling landscape is incredibly green, with open fields and dark woods on the horizon. In his youth, Columbus was much closer to the country than it is now, and sometimes it is hard to believe he was not thinking of Ohio when he was painting New York State. He saw lots of Eugene Speicher and Charlie Rosen, whose daughter he painted.

During these summers, George Bellows turned out an incredible amount of work. One glorious October in Maine, he knocked out forty-two canvases. That's the way Van Gogh worked when he was going good, one picture in the morning and one in the afternoon. Occasionally, he used the little ones as studies for a big studio picture. These are mostly landscapes, of course, and they are amazingly vivid. When Bellows talked about painting, he wasn't so great, but he could *do* it, and the less he thought the better. This is only one kind of a painter, but it's the kind Bellows was. Some of the big studio pictures you can criticize. Of course, he didn't work at top speed all the time, nobody can. But he was a prodigious worker, and he turned out as much work in his forty-two years as most men do in a lifetime. He caught that magic moment more than most: the dew on the hillside, the kids in the farmyard with the calf.

He painted Emma a lot, and did two big portraits of his mother. He was very fond of his daughters, no doubt about that. Many artists paint their children, but not as much as he did. He was enchanted by childhood, with its wild picturesqueness. Like most realists, he was fascinated by other people's lives.

For a man who liked to draw, there are surprisingly few sketches. He worked up four big canvases from the thirty-odd panels he painted on Monhegan in 1911, and there are studies for the fight pictures, but like Henri, he believed that if you're going to paint, paint. However, Henri always painted from a model and he painted the exact pose. Dempsey and Firpo didn't pose for Bellows. What happened to the starts, the unfinished pictures? He died suddenly, so surely there was something on the easel? Evidently, he just started in, which is what Henri did.

Bellows taught at the League off and on, but he never got caught in the role of the great teacher, like Henri or Sloan. He didn't believe that what he had to say was all that important; he didn't have all the wisdom of the ages wrapped up in a set of profound sayings. He breezed in and out of class, always a famous man, and the students got a kick out of him, but he didn't play the great George Bel-

lows, then or elsewhere. He had too good a sense of humor to take himself seriously. He did not believe in his own profundity: he had no special message. Heavens, it's all around you, paint it! Besides, he didn't have the time, or the patience. Bellows' teaching never cut into his work, you can be sure of that. And then Bellows had the great advantage that he never outlived himself, as Sloan did, or Henri. We have no tradition of the grand old man in art. It's not a role our men fall into naturally; mostly they fall into bitterness.

If Bellows had not died in 1925, he would have roared right through the Twenties, enjoying every minute of it. In 1929, sales would have stopped, and things would have been a little rough in the Thirties, but he would have made out all right because he was so far out in front. If there were any sales, he would have made them. Besides, he had a little money behind him, and in the Thirties, that made all the difference in the world. He would have survived the Depression; his kind of art was popular right up through the War. He would have been going great when Speicher, Rockwell Kent, and Walt Kuhn were making their big hit.

He was spared the triumph of abstraction after World War II. It was pretty rough on people like Speicher and younger men like Reginald Marsh, who had every reason to believe that they would end up the leaders of American art. They didn't. Victory went elsewhere; that's what victory is apt to do. When Bellows died of appendicitis in 1925, it was pretty much his fault: he couldn't believe there was anything wrong with him. Besides, in those days people popped off suddenly for the damndest reasons. He left a very unprepared family, but Emma survived. She was too powerful a woman to be a favorite of his artist friends; she didn't always agree with them any more than she agreed with George. She was pretty much the boss around the house: she didn't interfere with George's painting, and he didn't interfere where the children were concerned. She devoted her life to George living and George dead. She was an inspired widow. He was very fortunate in his posthumous career, and Emma was mainly responsible for that. Most artists are forgotten when they die; Emma saw to it that George Bellows was not forgotten for one minute. His friends did what they could, but friends are so often ineffectual. The sudden shock of his death may have helped, but other men have died suddenly. Emma worked on every show—from the retrospective at the Metropolitan in 1925 to the one-man show at the National Gallery in 1957. It was

her life. She was indefatigable, she lived and breathed Bellows; her widowhood lasted twice as long as their life together. Black-haired, statuesque, she never changed—she was Mrs. George Bellows.

Bellows was also singularly fortunate in his dealers. The Allisons, father and son, have handled practically nothing but Bellows since he died. Stieglitz knocked himself out for his artists, but he had a whole group, and he had his own work, and he had O'Keeffe. The Allisons made the market for Bellows, they stood by his work and the family all through the lean years.

Bellows may have influenced his contemporaries by his example, but not too much by his work. He had no pupils as such, no followers. He was still a young man when he died, and the disciples come later, when your own work is done. Nobody took down his great thoughts, the way they did with Henri or Sloan. He stands on his work. As he himself said, "a great present is the best guarantee of a great future." That's the way he felt about it, and that's the way it has been.

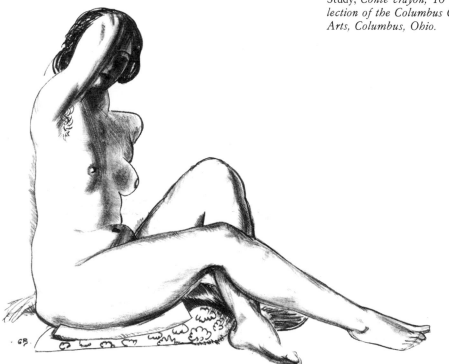

Study, *Conté crayon, 10" x 12⅝". Collection of the Columbus Gallery of Fine Arts, Columbus, Ohio.*

Color Plates

Plate 1
RIVER RATS
1906
30½" x 38½"
Oil on Canvas
Everett D. Reese Collection, Columbus, Ohio

Though Columbus is on two rivers, you would never guess it, so the New York waterfront was a revelation to Bellows. These early New York pictures have an air of dark and sinister power that disappeared from his later, brighter pictures. The New York docks were, and are, a pretty forbidding world. This is the first of the swimming pictures, a world of youthful strength and daring far removed from the YMCA pool on Front Street in Columbus. Bellows had come a long way in the two years he had been in New York.

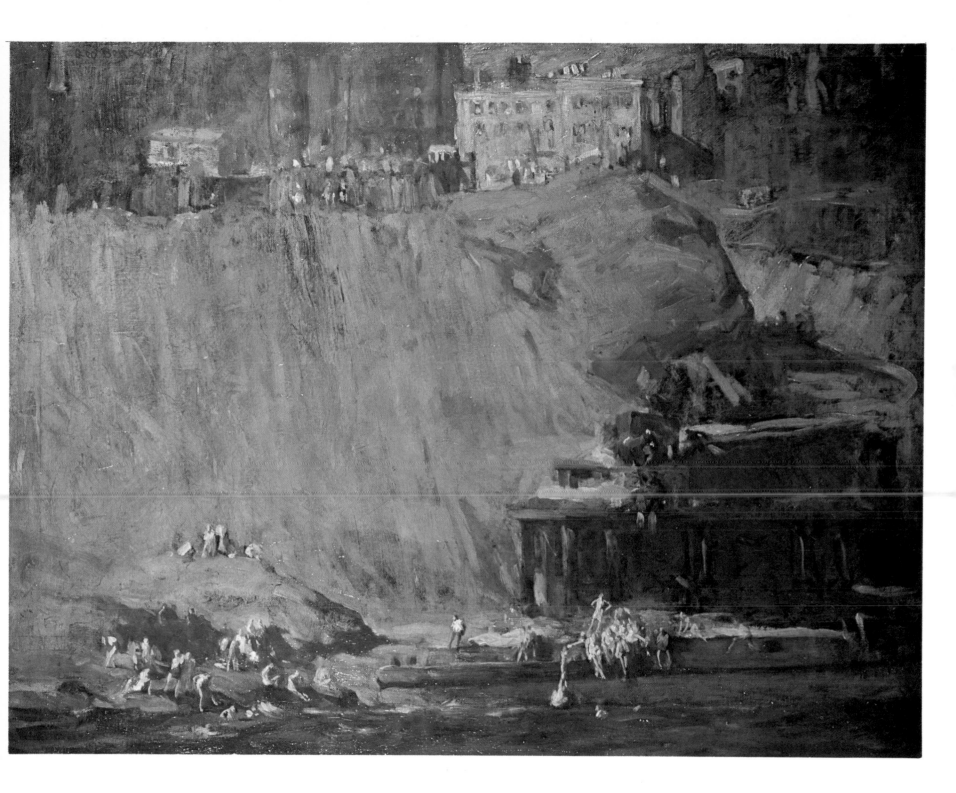

Plate 2

PORTRAIT OF MY FATHER

1906
28½" x 22"
Oil on Canvas
Columbus Gallery of Fine Arts, Columbus, Ohio
Gift of Howard B. Monett

Bellows painted his father more affectionately than he spoke about him, and the portrait may be a lot more like the old man than the son's stories. Sons are never reliable when they talk about their fathers; they should not be allowed as witnesses. Bellows never had a good word to say for his father. They had nothing in common. Without saying what they were, Bellows regarded his father's ideas with horror: the old man was a Republican and a Methodist, while Bellows was about as far left as you could get, a socialist, a Bohemian, and an artist. After all, who wants his son to be a painter? Yet the old man backed Bellows all the way. If he expected any affection in return, which he probably did not, you can be sure he didn't get it. Yet Bellows' painting of "Honest John" shows a crusty character who was certainly competent and hard-working, and may well have been fun to his friends. His wife and son didn't have much time for him. Considering how badly they got along, this is a marvelously penetrating study of the old codger, painted with insight and detached affection. George Sand said that we *are* our parents, and maybe Bellows' father passed along his faith in good work to his brilliant son.

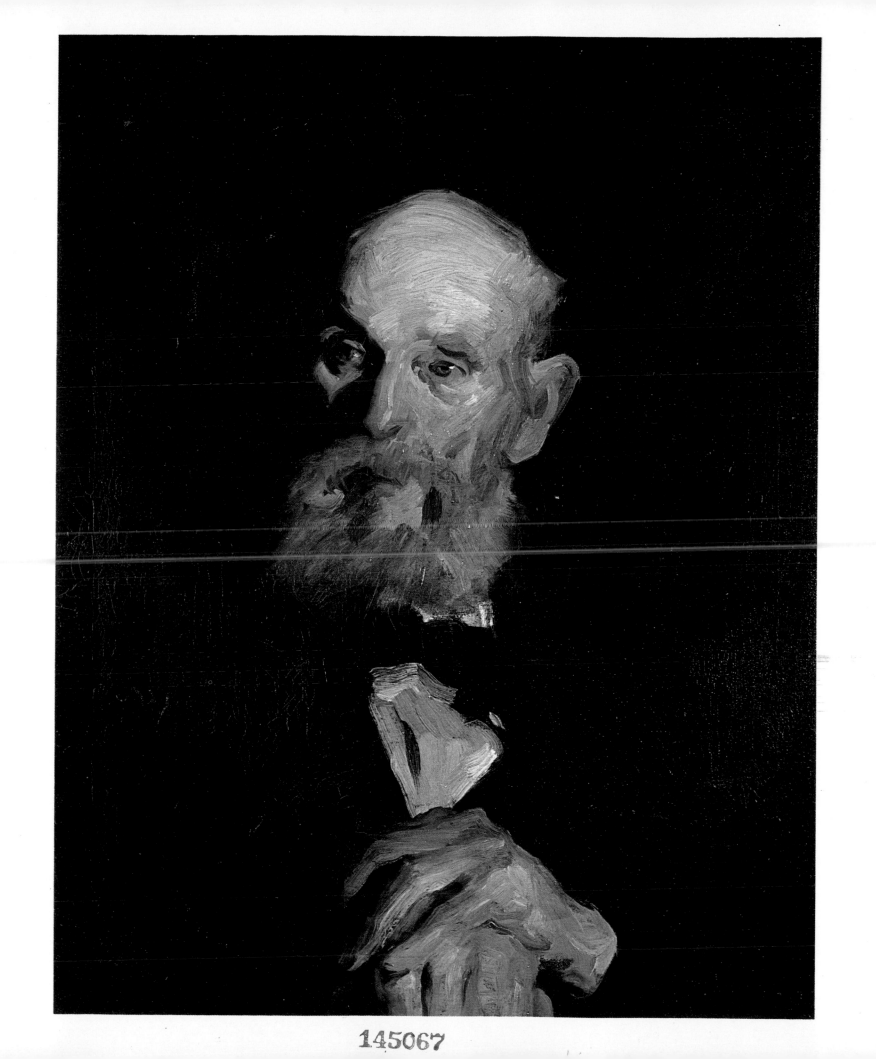

Bellows was an enthusiast about excavations, and indeed they have been one of the leading characteristics of New York in our time. He was not the only artists to tackle this subject, but he was one of the best. Other cities have excavations, but in New York they are continuous enough so that sidewalk superintendents are a recognized branch of the human race. Here is the start of the old Pennsylvania Station. If you go there now, you have trouble finding the new one.

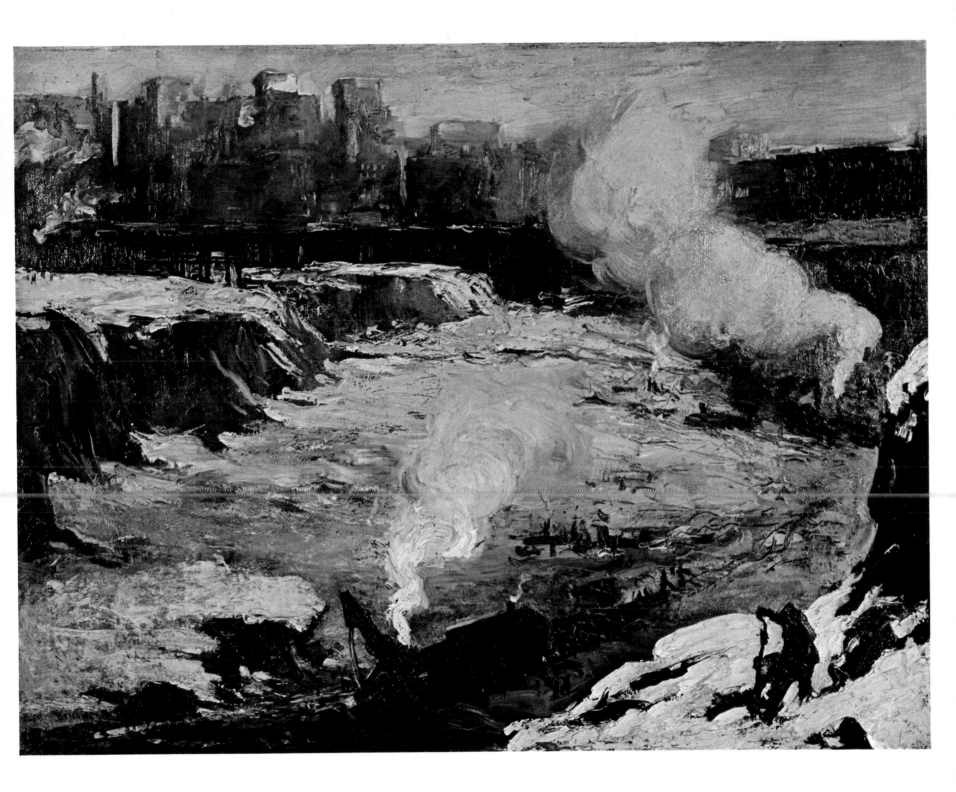

Plate 4

LAUGHING BOY

1907
24" x 18"
Oil on Canvas
Hirschl & Adler Galleries, New York, New York

In Bellows' day, tough kids were considered cute rather than problems: people didn't know about delinquents, but there were lots of them. Poor kids were just as different from the children of the rich as they are now. Duveneck made a reputation painting kids like this, but there had been countless shoeshine boys and newspaper sellers before he came along. This picture, which looks a lot like Luks, belonged to C. Ruxton Love, Jr., who owned sixteen paintings by Bellows, the largest and best private collection of his work ever put together. *Laughing Boy* was shown in 1909 by Henri at the MacDowell Club along with Glackens, Sloan, and Luks. That was a great honor. In a year or two, Bellows didn't need it, for he soon passed "The Boss" in popularity, though he was nowhere near as influential.

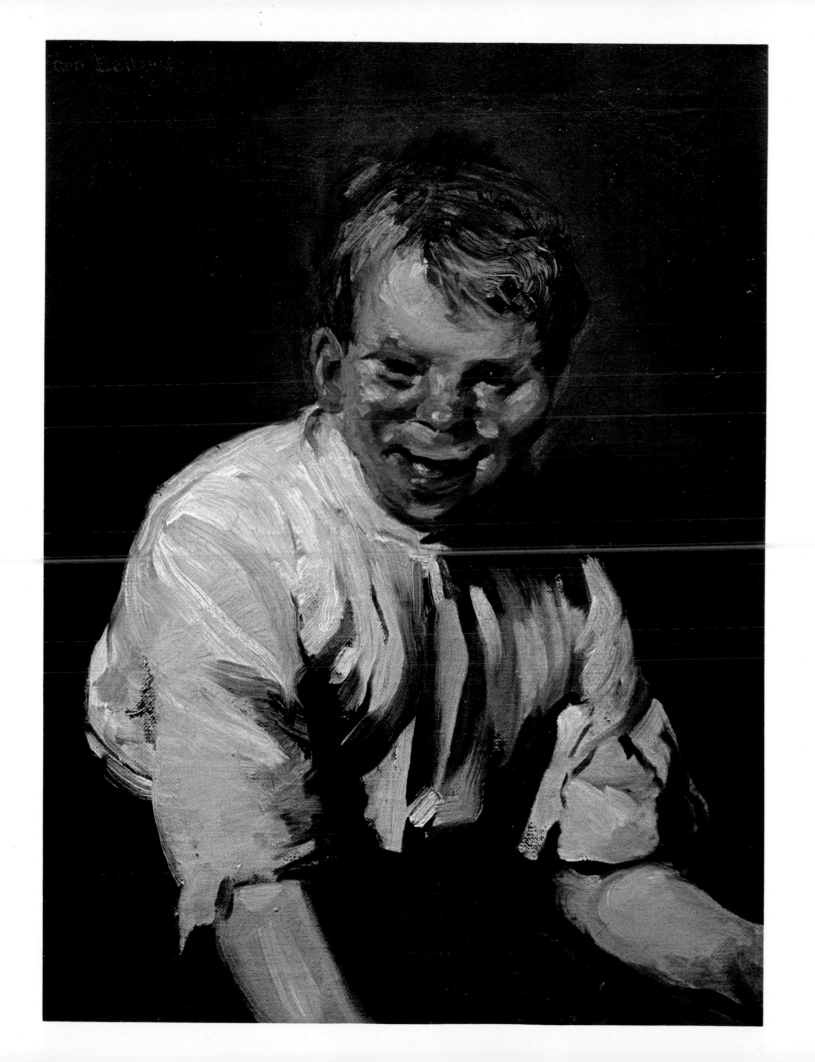

Sharkey's was a West Side saloon, not far from Bellows' studio, where they held prize fights in the back room. Public prize fights were illegal, but Sharkey's passed as a private club. Bellows hung out there quite a lot, making sketches. This is the best of his fight pictures. Sharkey's was located in one of those charming side streets off Central Park which were just as tough then as they are now. Compared to Nineteenth Street, they were somewhat lacking in old-world charm, but they had character, and that's what Bellows was looking for. *Stag at Sharkey's* may not be correct in drawing, but you must admit that it has the rush and wallop of the ring.

Bellows had no illusions about boxing. Compared with baseball it's a bloody affair. He saw the hangers-on around the ring as the scum of the earth, but it was a wonderful fight, and he caught the sheer joy of fighting, the strongest intoxicant known. Love is child's play; it's fighting that makes the world go round. People love fighting more than anything in the world, and they will die to get it. In our sporting world, it's as close to death as you can get.

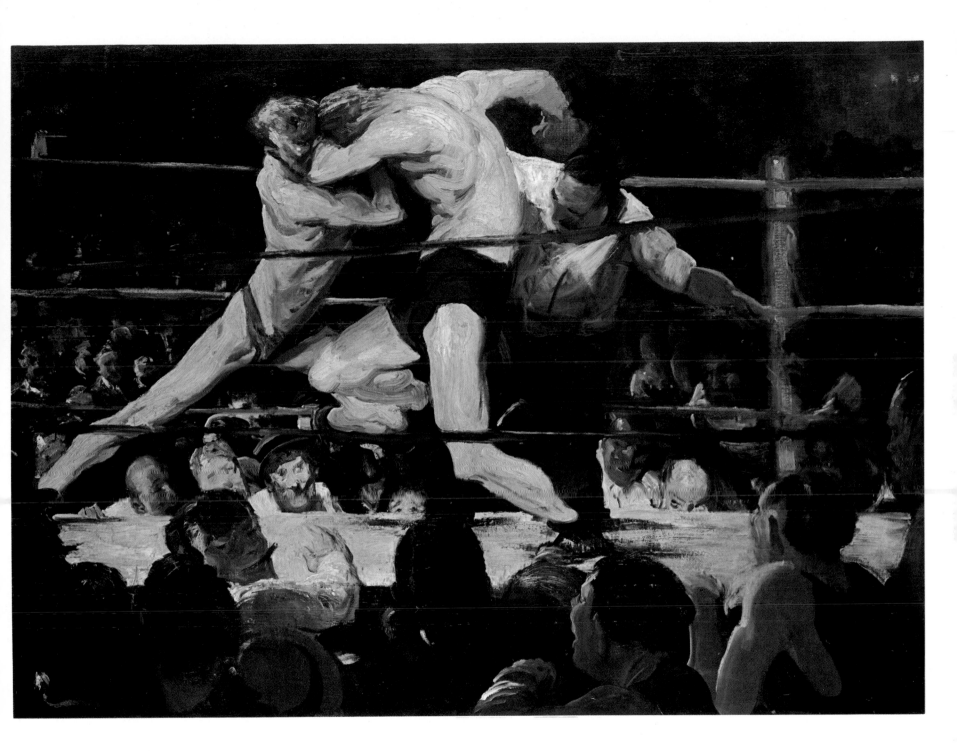

Plate 6

PORTRAIT OF AUGUST LUNDBERG

1907
25" x 18"
Oil on Canvas
Hirschl & Adler Galleries, New York, New York

Lundberg was a local character, a member of the small artistic circle in Columbus at the turn of the century. He was born in Denmark and worked as a scene painter, but he painted on weekends and wanted to be a great man. He had a picture in the Armory Show in 1913, probably because of Bellows. This was the peak of his career, and from here on out it was mostly shoals and misery.

He and Bellows were friends, but that does not mean they agreed on anything. They could not have been less alike. Compared to Lundberg, Bellows was an Arrow collar type, without the hair, while Lundberg's clothes looked like an unmade bed. If Bellows liked a painting, Lundberg said it was no good. He was about the only man Bellows ever fought with. But it was easy to disagree with Lundberg. For this moody great Dane, Bellows' success must have been exasperating beyond endurance.

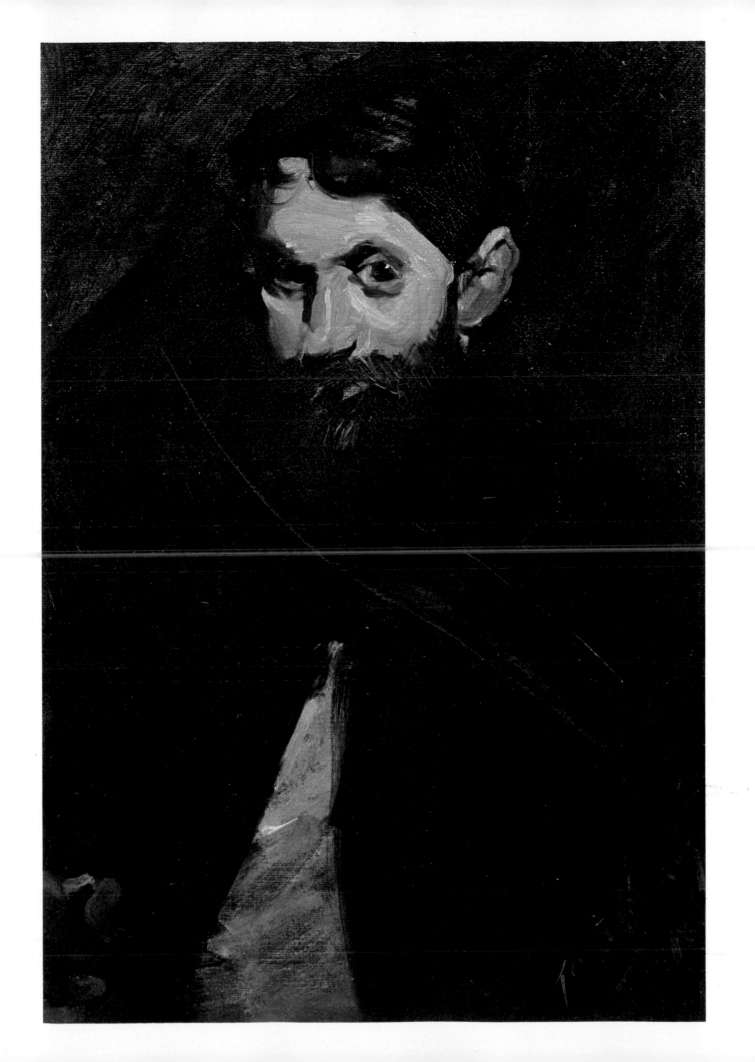

Plate 7
NORTH RIVER
1908
32¾" x 42¾"
Oil on Canvas
Pennsylvania Academy of Fine Arts, Philadelphia, Pennsylvania
Temple Fund

This is the first painting Bellows sold to a museum, and he was doubly pleased because the Philadelphia Academy had the best collection of American pictures in the country. From Hoboken and Weehawken the Hudson is so built up these days, with apartment towers on the Palisades and condominiums in Fort Lee where the old movie studios used to be, that it's hard to recognize the scene. Maybe it's farther north: the North River runs all the way to the Harlem River, though actually they're all arms of the sea. New York is a curiously land-bound city, considering that it's surrounded by waterways that rival those of San Francisco.

Several other Henri students painted the same subject, but the Master said: "You have all observed that ships go up and down stream. This is the only one that shows they cross it as well." When shown at the Pennsylvania Academy, this painting was Bellows' first public success, and it made his reputation. The *New York Times* referred to "the rugged and almost startling reality [of] the amazingly clever canvas by George Bellows called 'North River'" and said it was "the best piece of work produced by this young man so far." According to the New York *Herald Tribune,* it was "one of the most original and vivacious canvases in the show. . . . An artist need never leave Manhattan Island if it yields him pictures like that." It received a prize, and Charles Morgan calls it "The cornerstone of his reputation." On the official notice, the perpetual secretary of the Academy, Harry Watrous, wrote: "Keep up the good work, my boy, I have my eye on you." That was a great day!

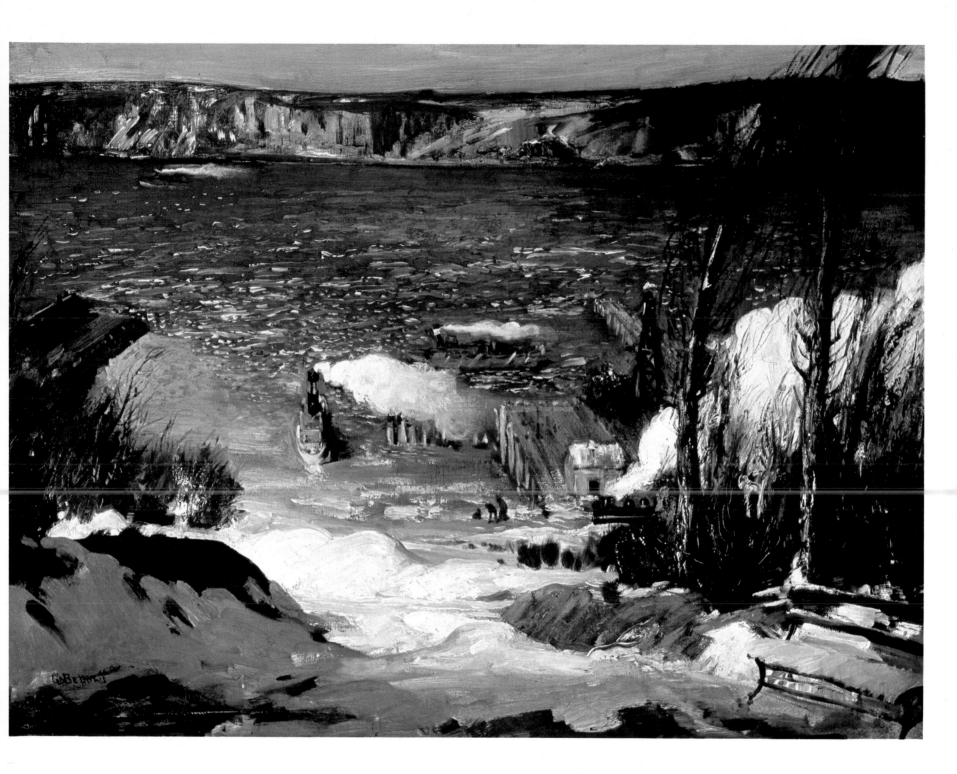

Plate 8

STEAMING STREETS

1908
38½" x 30"
Oil on Canvas
Santa Barbara Museum of Art, Santa Barbara, California
Preston Morton Collection

If Bellows was miffed at not being included by Henri in the great exhibition of "The Eight" in 1908, he didn't show it. He certainly shared their material. Henri had painted snowy streets, and Glackens specialized in the accidents and incidents of city life. We waste a lot of nostalgia on the good old days, but it was hell on horses, for they are afraid of falls and they panic easily. The good old days were not all sweetness and light, but the streets were full of good subjects for illustrators, which Stieglitz' camera was not fast enough to catch. Winter was colder then, and the weather seemed worse. This is the only piece of violent action in Bellows' work outside the sport pictures. The horse did not always know the way; the teamsters got drunk and fell under the wheels. Olin Warner, the sculptor, managed to get killed in a Central Park crash between a bicycle and a hansom cab.

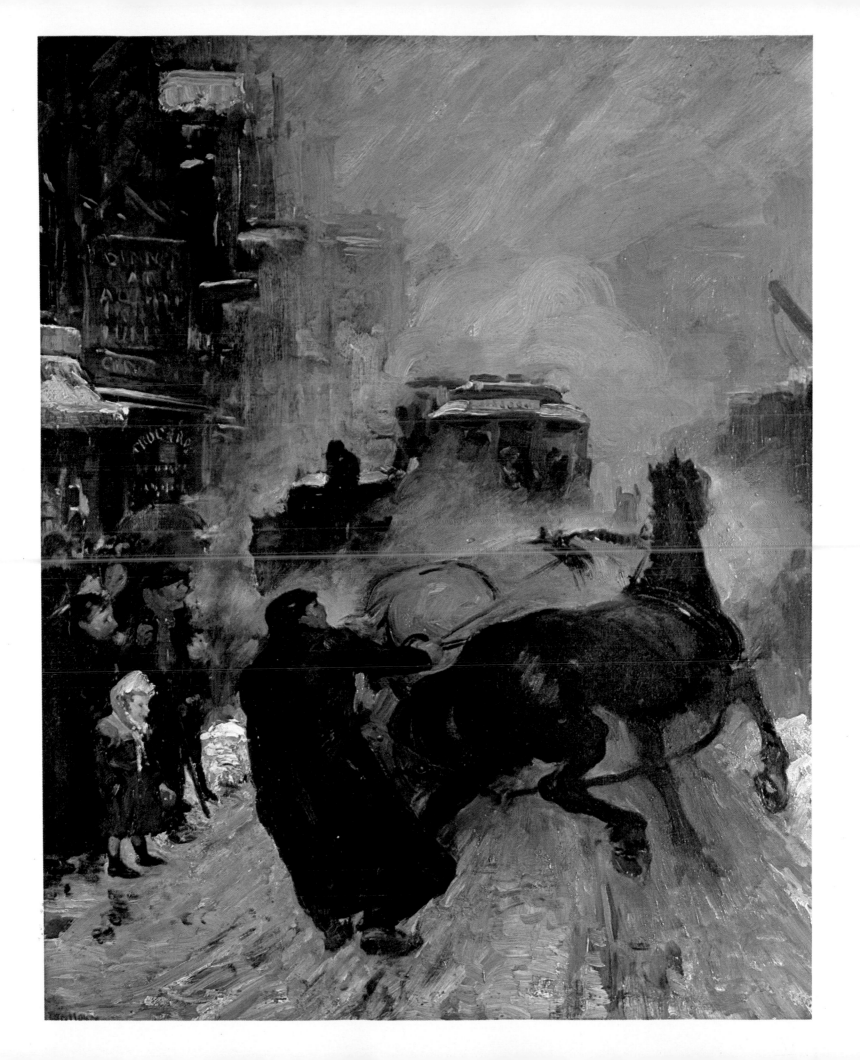

Plate 9
UP THE HUDSON
1908
35⅞" x 48⅛"
Oil on Canvas
Metropolitan Museum of Art, New York, New York
Gift of Hugo Reisinger

Bellows got another fine picture out of the same scene as *North River.* People appreciated the beauty of the river more than we do now; they traveled on it more, and they had not been trained to think it was dirty. It was their river and they were proud of it. Look what the French have made of the Seine, which is a very ordinary river indeed. Bellows used American subject matter quite naturally, without any unlikable nativism. He worked hard on this picture, restretching the canvas several times to get the right shape, which is unusual for any painter and remarkable for a slap-bang man like Bellows. Bellows had a fine sense of place, and he reminded New Yorkers of spots they saw every day. We are so taken up with our own cultural explosion that we forget how much people cared about art sixty-five years ago. Henry Geldzahler says that "Bellows' commitment to paint only what he saw is evident in his *Up the Hudson.* This is a wide and open landscape, filled with air and light, very different in feeling from the denser work of Ernest Lawson." He feels that Bellows' success "was largely due to his extraordinary technical facility and the ease with which he learned, but it is also worth noting that by the time Bellows' work appeared, the major battles had been fought and won by the Henri group." That may be, but it would not explain Bellows' appeal today: quite simply, people like what they see in Bellows, and they admire the same things in his paintings that his contemporaries did.

When this picture was exhibited in a traveling exhibition of American art at the Detroit museum, one critic said that the water seemed to run uphill, but then you can't please everybody. Hugo Reisinger, a New York collector, bought it and gave it to the Metropolitan, which was just as much of an honor for a man under thirty in those days as it would be today.

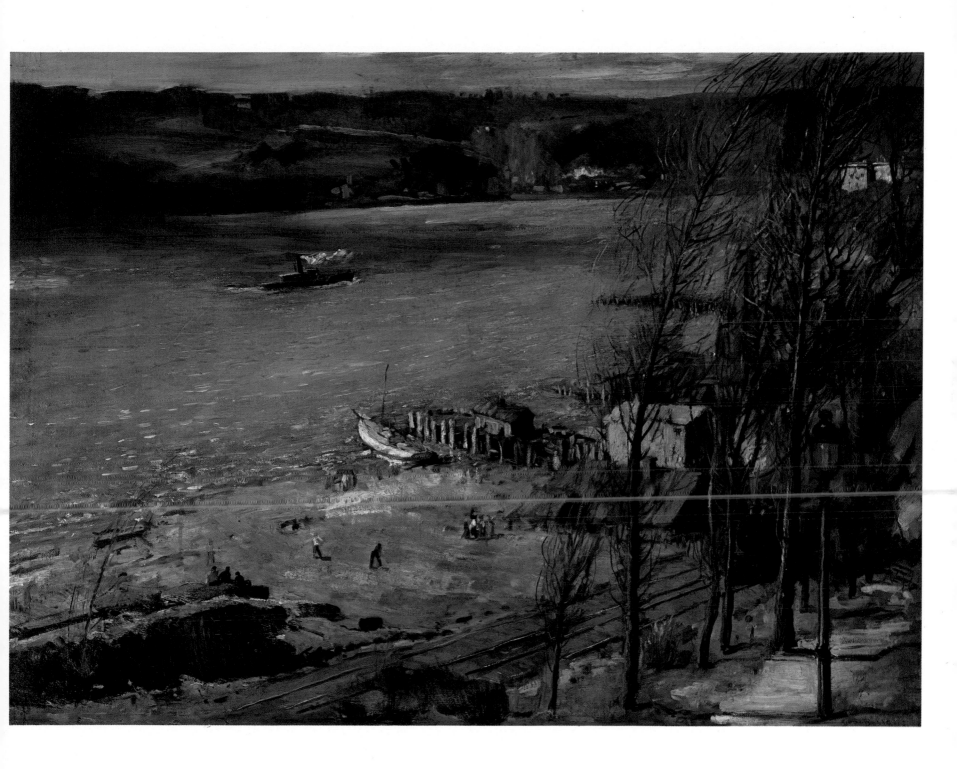

Plate 10

THE BRIDGE, BLACKWELL'S ISLAND

1909
33½" x 44"
Oil on Canvas
Toledo Museum of Art, Toledo, Ohio
Gift of Edward Drummond Libbey

In Paris, tramps sleep under bridges; in New York, you could put a cathedral under a bridge, with room left over for parking lots, second-hand cars, and apartment houses so tall that the smoke from power plants can blow in their windows. The Queensborough is no mere slip of a bridge, even by today's standards: you can hang lane after lane of traffic on it, and it does not give a damn. And it's still the best way to get to the airports. When Edward Drummond Libbey, the only begetter of the Toledo Museum of Art, bought this picture in 1912, he wrote to the Director: "You need not hang this painting now unless you want to. I feel that someday it will be important, for the painter shows great promise."

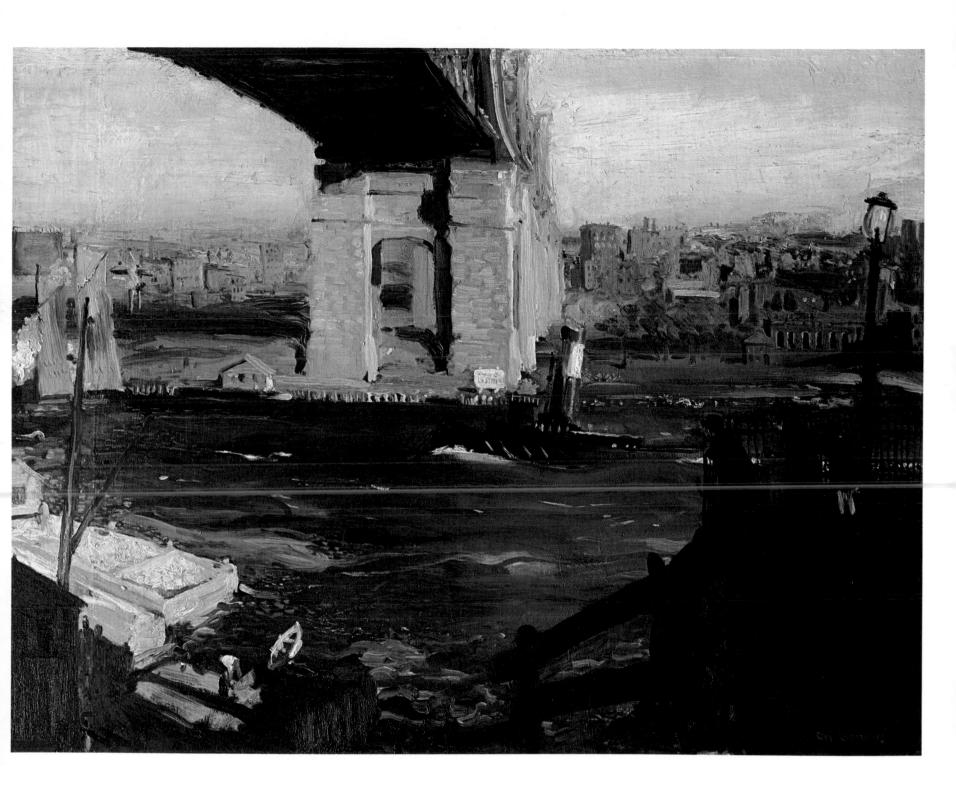

Plate 11

BOTH MEMBERS OF THIS CLUB

1909
45¼" x 63⅛"
Oil on Canvas
National Gallery of Art, Washington, D.C.
Gift of Chester Dale

At saloons like Sharkey's you paid dues to get in, which made the murder lawful. This is the other great fight picture, and the biggest picture Bellows ever painted. If the boxers aren't breaking clean, at least you have no doubt that there is a fight going on. And what a fight it is, all the better for being black and white. The faces around the ring look like lunatics out of Goya. They are! Bellows said: "I don't know anything about boxing, I'm just painting two men trying to kill each other."

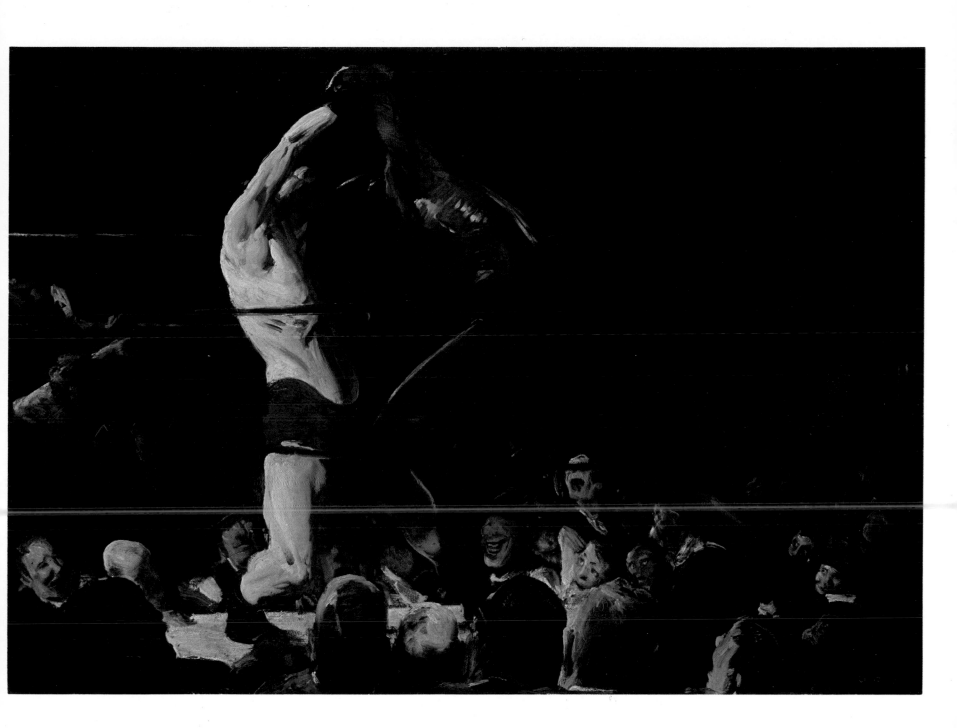

Plate 12

LONE TENEMENT

1909
36⅛" x 48⅛"
Oil on Canvas
National Gallery of Art, Washington, D.C.
Gift of Chester Dale

There are a lot more lone tenements now than there were in Bellows' day. You could take this picture in Bedford-Stuyvesant today. There is a wonderful desolation about this picture. It was painted just after *The Bridge,* and shows the same river and island view. Work is still going on at this site: they are digging a new subway tunnel, and the tugs still chuff and chatter back and forth. New York makes any other American city except Chicago look dead on its feet.

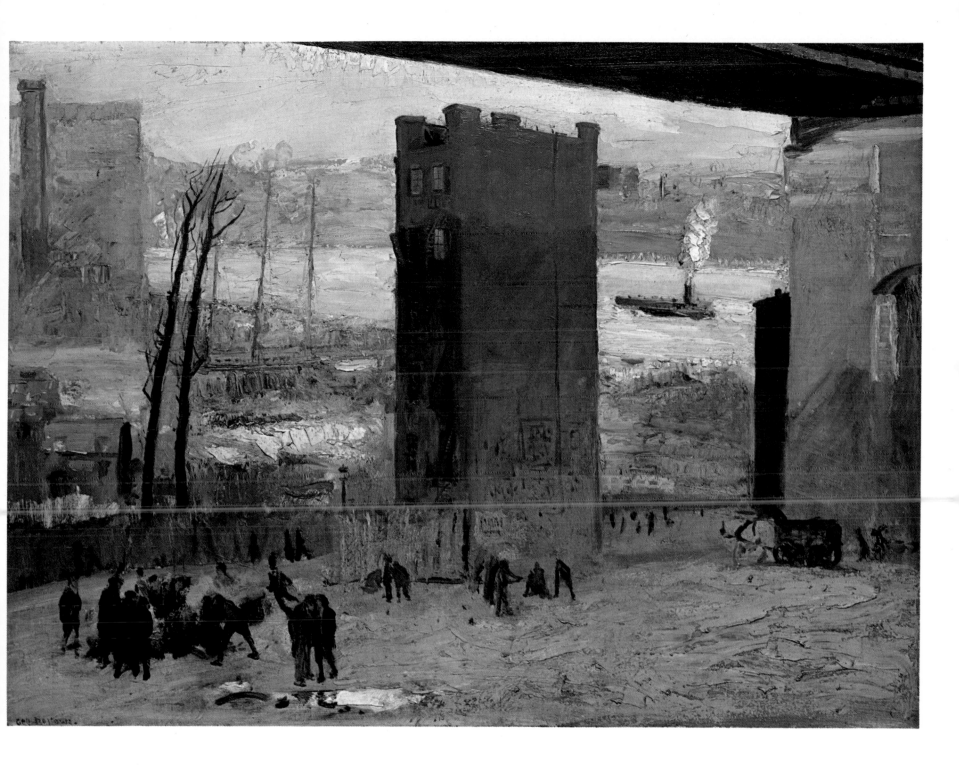

Plate 13

SUMMER NIGHT, RIVERSIDE DRIVE

1909
35½" x 47½"
Oil on Canvas
Columbus Gallery of Fine Art, Columbus, Ohio
Bequest of Frederick W. Schumacher

Bellows celebrates the small seas of tranquility as well as the great raucous city. Before nights became dangerous, Riverside Drive was one of the best parts of town. The view across to the Palisades is wonderful, but New York is curiously inward, and doesn't seem to give a damn about the beauty all around.

It's hard to paint the night, but Bellows hit it off admirably. There's a cool breeze off the water, and lovers are everywhere. It will get cooler towards dawn, but tomorrow will be another scorcher. This picture cleaned up beautifully—for years there were no people in the park!

This hymn to the great Olmsted park is a piece of city poetry. Here are the girls in their summer dresses, and the breeze ruffling the reflections in the water. It is one of Bellows' few night pictures, and it deserves to be called a nocturne. *Summer Night* belonged to Frederick W. Schumacher, who gave it to The Columbus Gallery of Fine Arts along with the rest of his collection. Columbus did quite well by Bellows, better than most American cities do by the local talent. The other great local collector, Ferdinand Howald, bought a dozen Glackenses and a dozen Lawsons, but nary a Bellows.

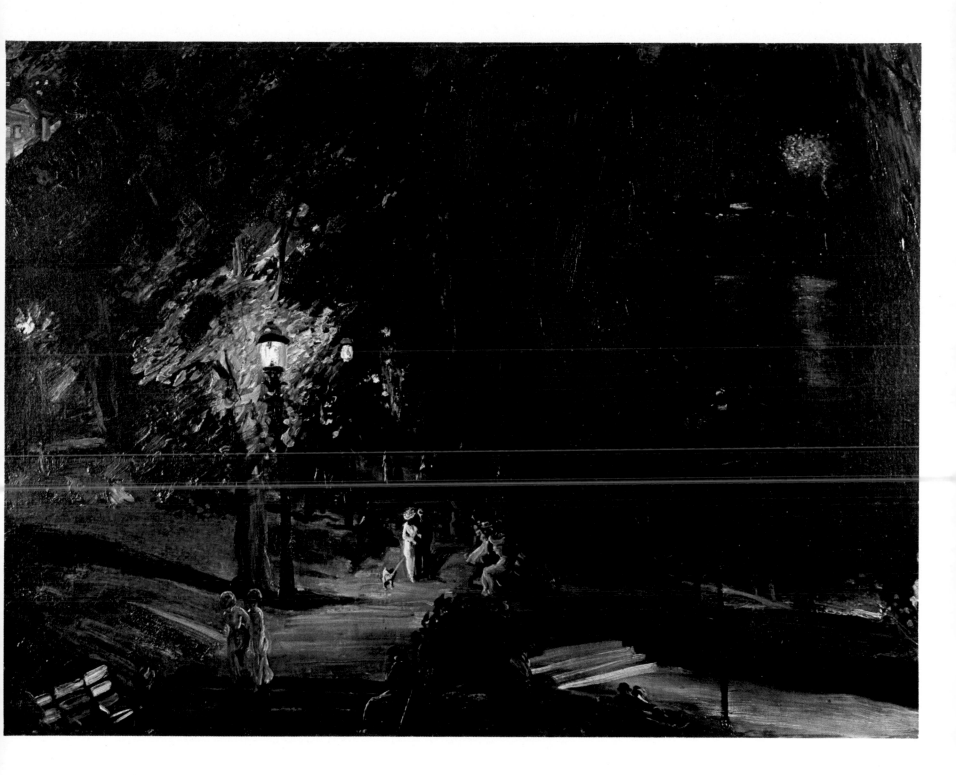

Plate 14
BLUE MORNING
1909
31⅝" x 43⅜"
Oil on Canvas
National Gallery of Art, Washington, D.C.
Gift of Chester Dale

For a man who loves construction, New York is the place to be. There's more going on in New York than in the rest of the country put together. In a good year, they build a half dozen cities the size of Columbus. Pennsylvania Station was one of the great excavations of all time. People used to say it was Roman in its grandeur. Roman? You could drop the Coliseum or Pantheon into the hole. This is what we do best, and Bellows caught the sheer exaltation of it all.

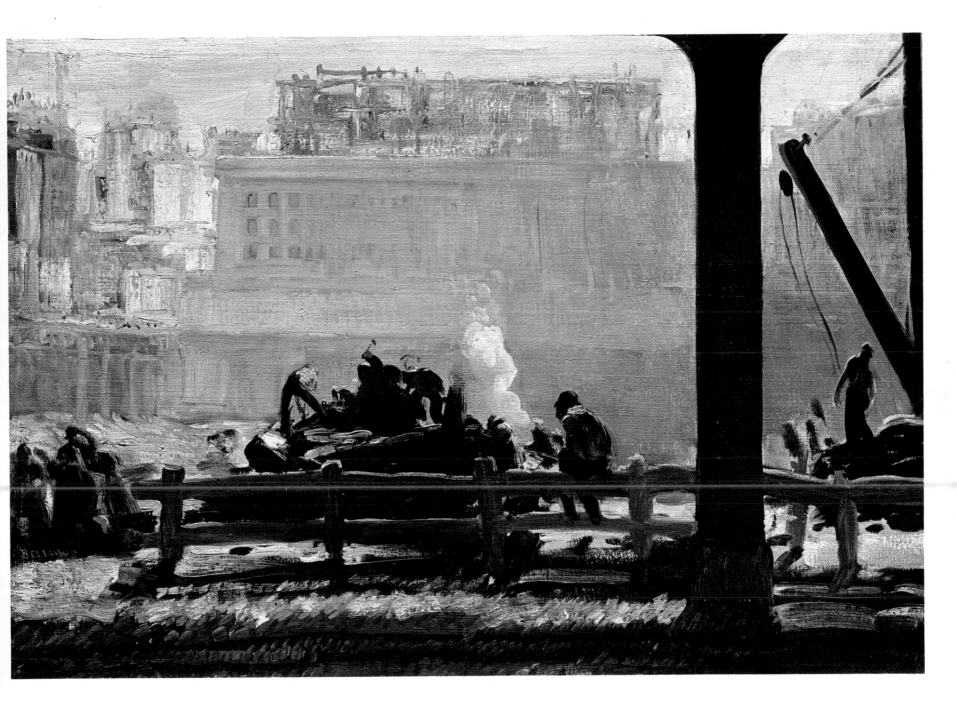

49

Plate 15
WARSHIPS ON THE HUDSON
1909
30½" x 38½"
Oil on Canvas
Joseph H. Hirshhorn Collection, Greenwich, Connecticut

The Fleet's In! That was a great day. The ships made a great stir in the river, with launches scuttling back and forth and sailors all over town and shore patrols beating them up on the 125th Street ferry. Small boys could visit the ships, and older ones too. It was a thrilling thought that those guns might go off, but it was pure holiday, and for Bellows it was pure spectacle. It gave him a chance to paint from Riverside Drive again, which is probably the best way to look away from New York. This picture has a curious pattern: it looks like a painting by Ernest Lawson, probably because of the banded arrangement of the shore, the river, and the cliffs across the water. Although Bellows rarely shows another painter's influence, he knew Lawson and his work very well. In our air-conditioned nightmare we have forgotten about summer nights made for long walks through the dark streets, long rides on the open trolleys which went like hell under the El, and love in the parks.

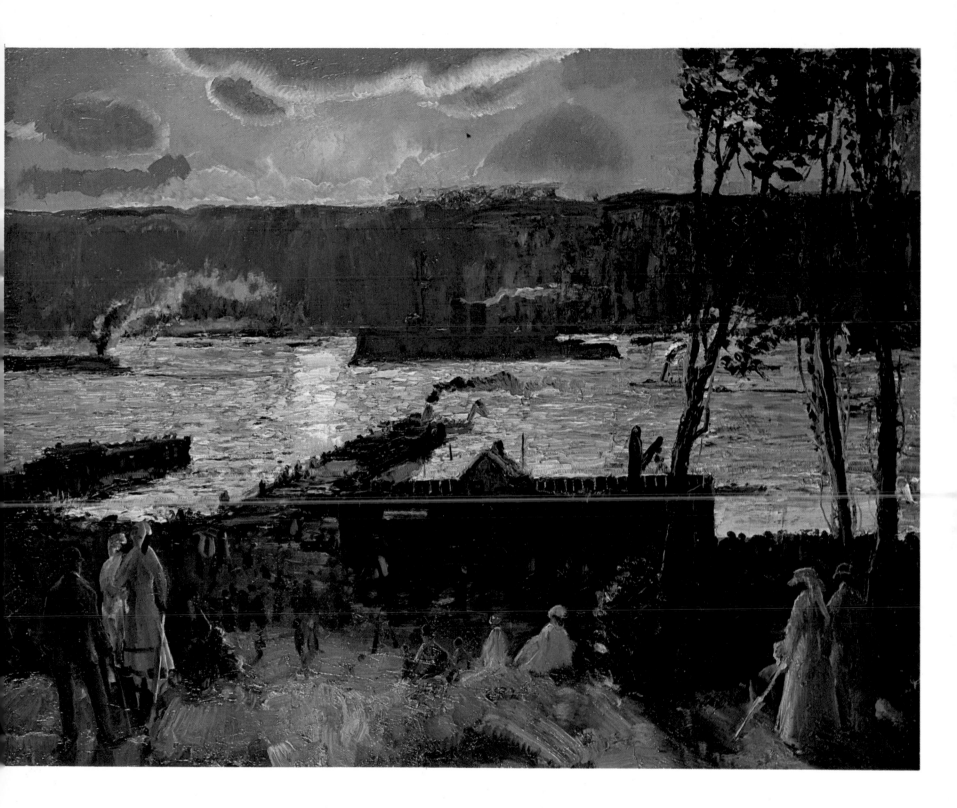

Plate 16

POLO AT LAKEWOOD
1910
45" x 63"
Oil on Canvas
Columbus Gallery of Fine Arts, Columbus, Ohio

Bellows' politics never interfered with his sports. Polo has always been a class game, and to many Midwesterners there's something phoney about it. It has never been popular, but the game has great rush, speed, and wild confusion. Bellows understood polo immediately. You'd think he'd been playing all his life, even though in Columbus, horses were for driving to church on Sunday.

Bellows, a happy socialist, did not mind painting the pleasures of the rich. He was against poverty and injustice, but he didn't want to turn the world gray. There is no social comment in this picture, just joy in the excitement and the wonderful horses. It's a dark day, but it won't rain till play is over. The little group to the right catches the spirit of the times far better than the photographs of the period, which lie lugubriously. These people are having a lot of fun.

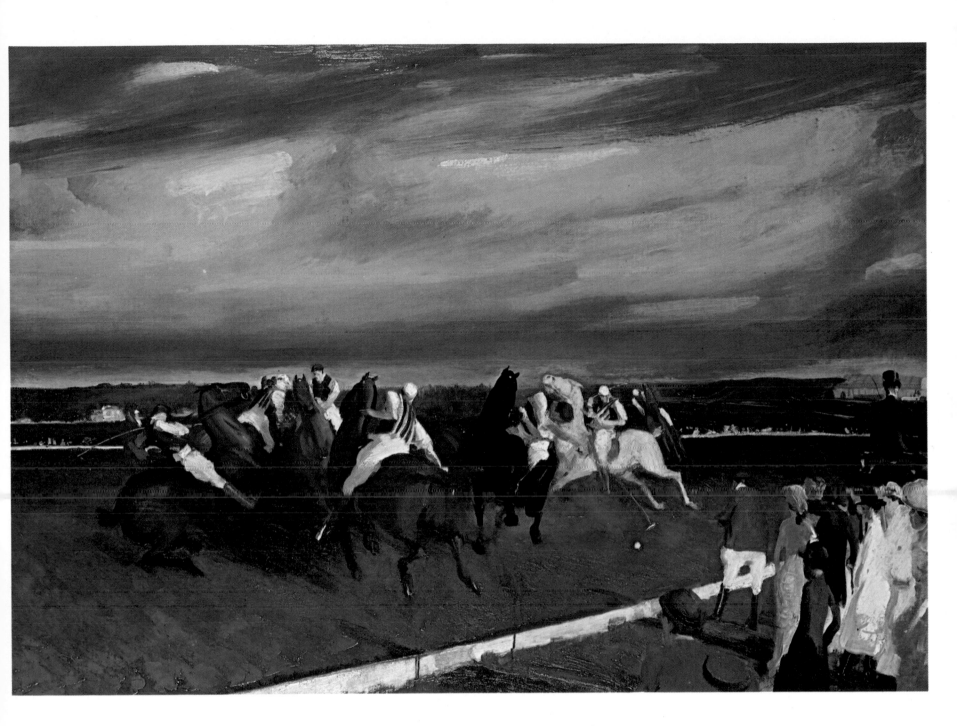

Plate 17

BLUE SNOW, THE BATTERY

1910
34" x 44"
Oil on Canvas
Columbus Gallery of Fine Arts, Columbus, Ohio
Ferdinand Howald Fund

Bellows painted the city from one end to the other, in all kinds of weather, from summer night on Riverside Drive to winter along the Battery. Here it's a beautiful, clear winter day, and the wind is off the water, so you can't see the coal smoke which blanketed American cities in those days with the real smell of winter. Bellows enjoyed snow, perhaps because there was not much of it in Columbus. Somehow you never get tired of snow in central Ohio the way you do in Upstate New York. Bellows got a great kick out of it, like his friend Rockwell Kent, but Kent was a fanatic. Bellows enjoyed the snow when it came, but then, he enjoyed everything.

The paths make a good pattern for the picture, and the blue shadows are convincing. Bellows was good at making you think you're there—he makes you believe it the way some people believe in the movies or the theater. These paintings remind people of places they have been, or think they have.

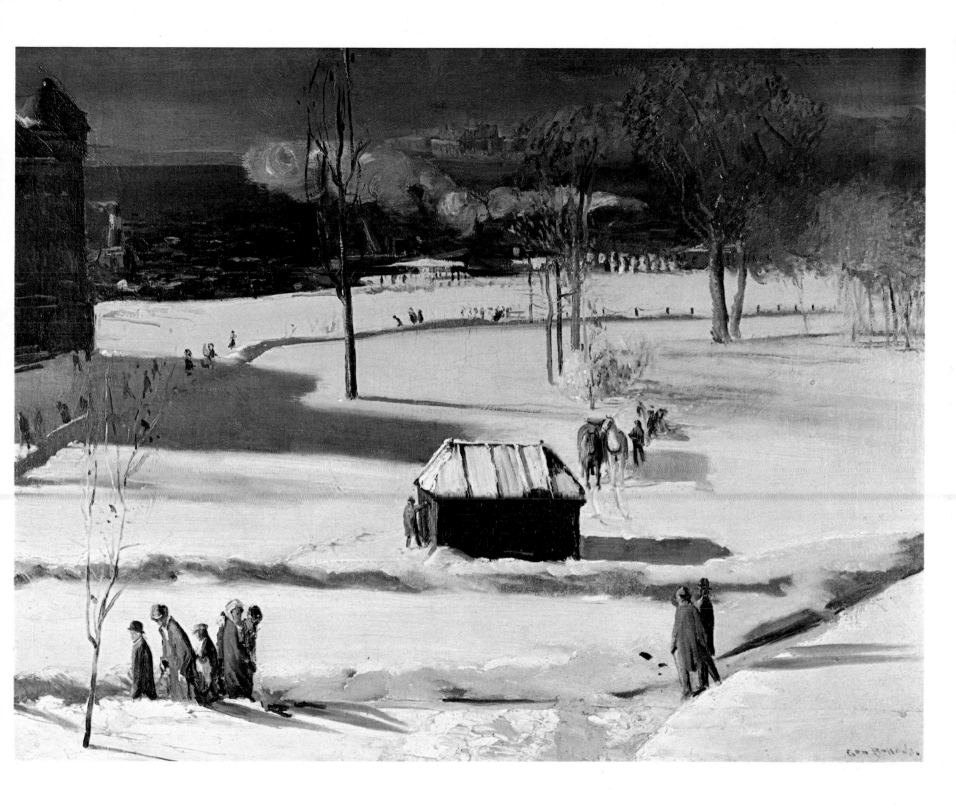

Plate 18
SNOW DUMPERS
1911
36" x 48"
Oil on Canvas
Columbus Gallery of Fine Arts, Columbus, Ohio

Snow stayed longer on the ground in those days, when there were no cars to chew it up. Actually, people made more of an effort to clear the streets then than they do now. It was hard work, but the bums and unemployed counted on it. Shoveling snow gives you a tremendous thirst for hot coffee and straight whiskey. It was hard on the horses, who always looked miserable in cold weather. The blankets didn't seem to do any good. Bellows is at his best painting the bridge, the buildings, and the boats, which still look like that today. Looked at closely, his horses are not very convincing; there's a slight note of romance. But nobody minded at the time, when God knows horses were all over the place and inspired more affection and admiration than trucks do today. Snow is still dumped in the East River, and the slums are much the same. This is another of Bellows' great cityscapes, and no one else has painted the subject.

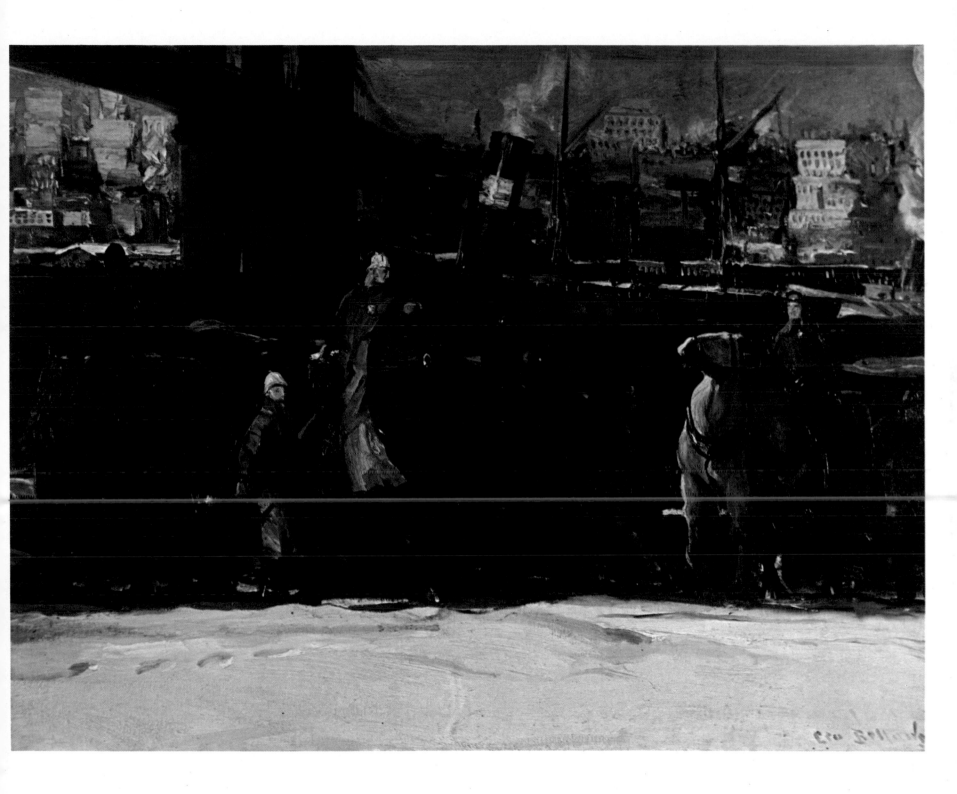

Plate 19
SHORE HOUSE
1911
40" x 42"
Oil on Canvas
Rita and Daniel Fraad Collection, New York, New York

This striking picture, painted in 1911 from a sketch Bellows made at Montauk on his honeymoon, has a real sense of the lonely moors, the cliffs, and the windmills of Montauk Point, an unusual stretch of country with deer and shifting sands that bury the stunted trees. Except for the lighthouse at the tip, it has been painted very little, which is strange, considering that there have been artists in East Hampton for the best part of the century. It is the most remarkable piece of country within a hundred miles of New York. You can still find lovely spots like this down along the shore, even though the village is beginning to look like Torremolinos or Waikiki. The end of Long Island has a wonderful sad feeling all its own, and Bellows caught it. This is the best Montauk picture ever painted.

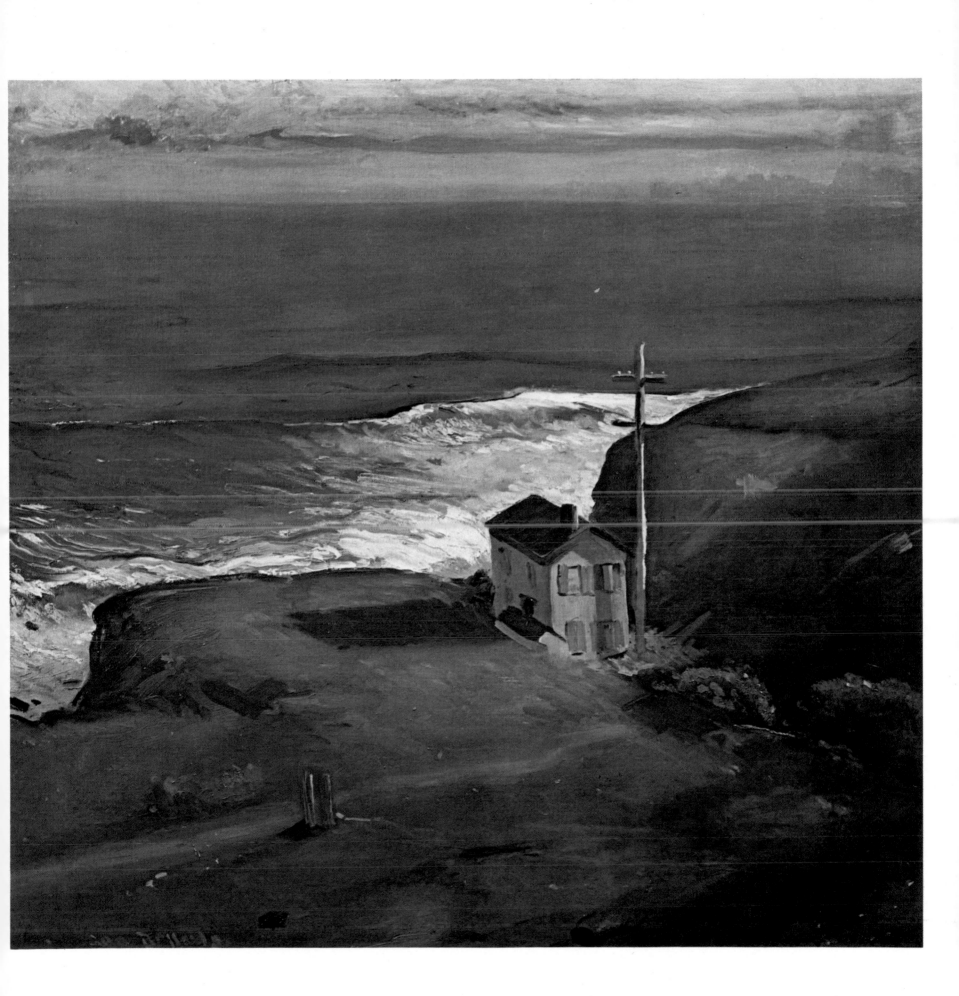

Plate 20
AN ISLAND IN THE SEA
34" x 44⅜"
Oil on Canvas
Columbus Gallery of Fine Arts, Columbus, Ohio
Gift of Howard B. Monett

There never was much mystery about Bellows, but he knew what he was doing when he painted this picture. You can tell his intentions from the title. People read poetry in those days and believed it, so that even Bellows was affected. This is not his usual fresh and dashing ocean, but a brooding island, coasted by Melville and Ryder, a world he rarely touched and seldom admired. He did not work up this subject and he was not looking for it, he just *saw* it. If he could see it, he could paint it.

The island, like the picture, has an unusually simple form, which is what attracted him. There are no tricks. Even the sky is plain, in bands, and the reflections on the water are right in the middle. You contemplate the wonder and mystery of the sea, and that's what he wanted you to do. Bellows is so original he can be completely unlike himself. Most painters are very limited; Bellows was open to all the world, including what he, and we, cannot understand, and he rarely missed. Bellows was the most straightforward of men and painters, a realist if there ever was one, and he certainly believed that things are what they seem. There are only a few touches of mysticism in his work, and this portrait of an island lost in a soundless sea is unique among his paintings. There is something wonderful about islands and he has caught it.

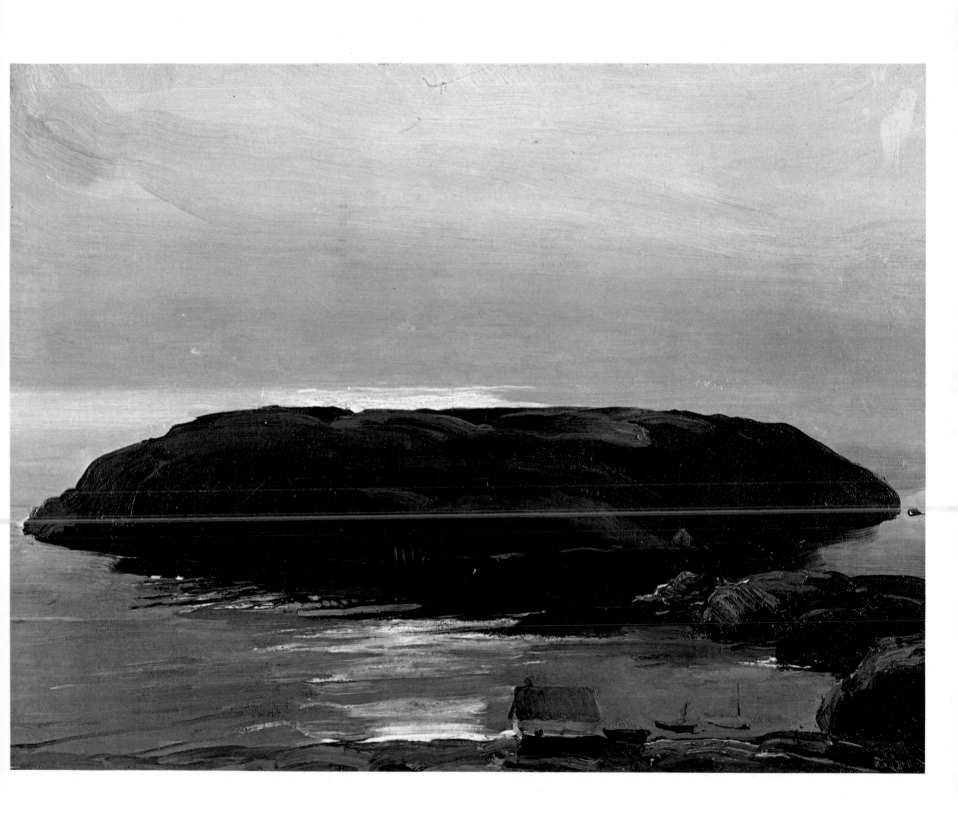

New York was a real port in those days, with the harbor full of ships and the giant liners going out, three, four in a day. Now the West Side docks are quiet, though there's still plenty of activity on the Jersey side. This painting was done from Brooklyn (only Marin painted the skyline from Hoboken and Weehawken, although it's one of the great views of the world). These early pictures of Bellows are probably the best things he ever did.

This picture was the first purchase of the Randolph-Macon Art Association: it was bought in 1920 by Dr. T. Woody Campbell, later professor of German at the College, who went to see Bellows at Nineteenth Street and told him about the plans to start a collection. Bellows was pleased that his picture had been chosen, but probably less pleased at the money he was offered. However, he said that most artists were less concerned about the price of their pictures than about having them in a place where they would be appreciated. And he was pleased that the girls were so enthusiastic.

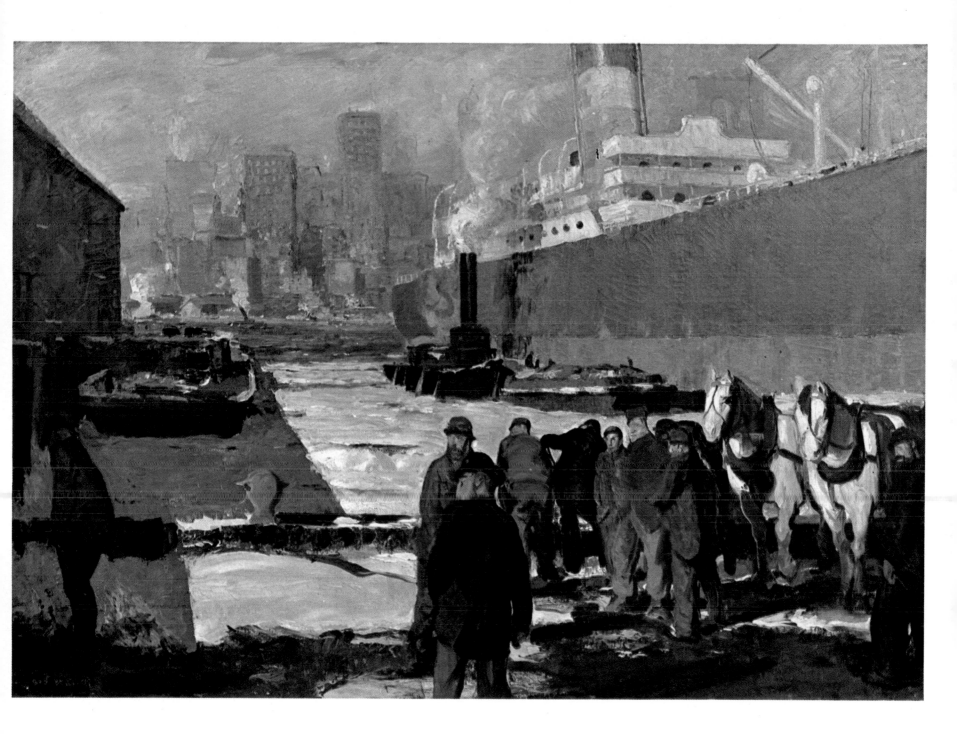

Plate 22
WINTER ROAD
1912
32" x 44"
Oil on Canvas
Hirschl & Adler Galleries, New York, New York

This is a relatively late winter scene, painted in 1912, after Bellows came to New York. He was so fascinated with snow, you'd think he'd never seen any in Ohio, but Columbus is so flat that there's no place for coasting. He wouldn't have had much chance to skate as a boy, that's for sure. This scene was painted after *Snow Dumpers* and just before *Men of the Docks.*

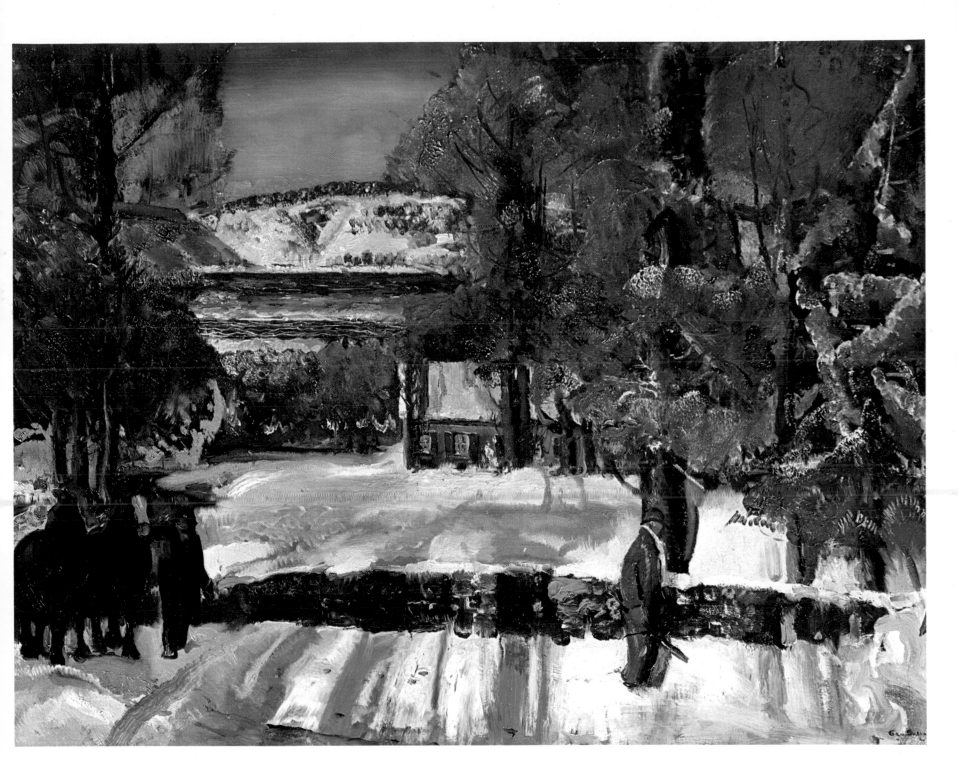

Plate 23

THE BAY NEAR NEWPORT

1912
14½" x 19¼"
Oil on Panel
Columbus Gallery of Fine Arts, Columbus, Ohio
Gift of Frederick W. Schumacher

This picture used to be called "Arcady," but that's a concept we don't use any more. There's nothing remarkable about the scene, just a string of islands and the two hilly shores. But it has a real air and a good bite; you can taste the salt. Bellows visited the shore in summer, when there are few storms, and salt water fascinated Midwesterners. The sailor may hate the sea, but those who do not have to live with it find it beautiful and romantic.

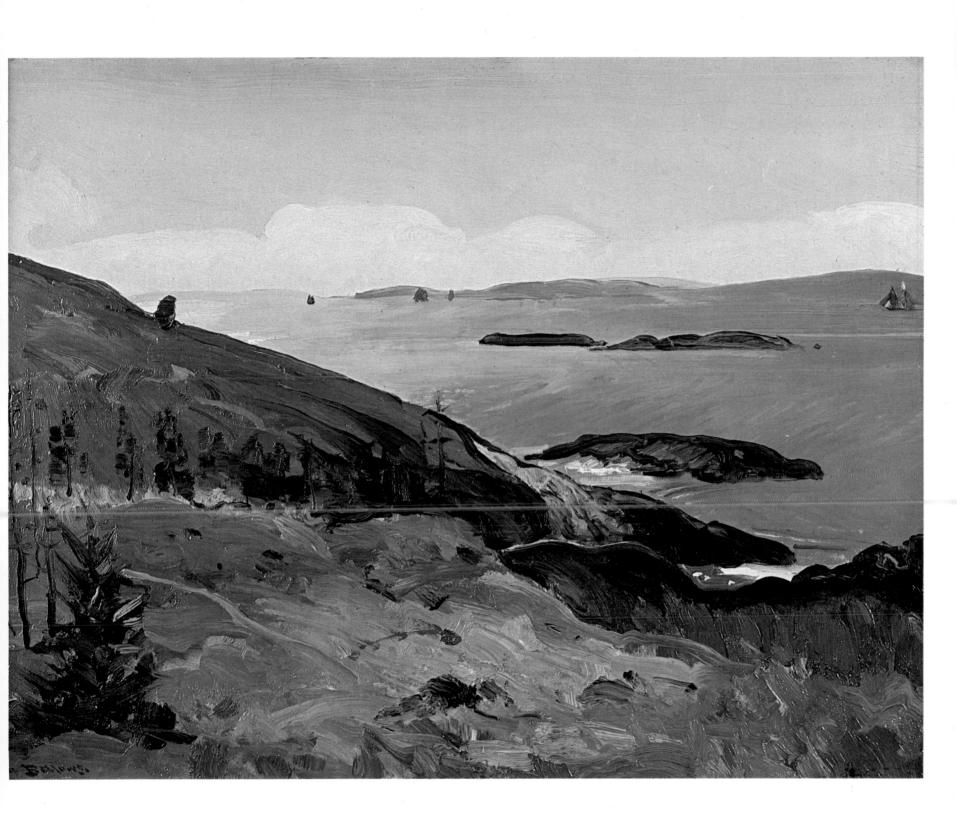

Plate 24
THE CIRCUS
1912
34" x 44"
Oil on Canvas
Addison Gallery of American Art, Phillips Academy, Andover, Massachusetts

Bellows was not fascinated by the circus like his friend Walt Kuhn, but he did very well by the immensity of the big tent and the graceful ease of the equestrienne. The horse may not make much sense, but Bellows wasn't painting a horse's portrait, he was painting a picture. Columbus was quite a circus town when he was a boy — Sells-Floto wintered there — but that was not the reason he painted this picture; Emma was helping put on a circus performance for a charity benefit in Montclair, and he had nothing better to do.

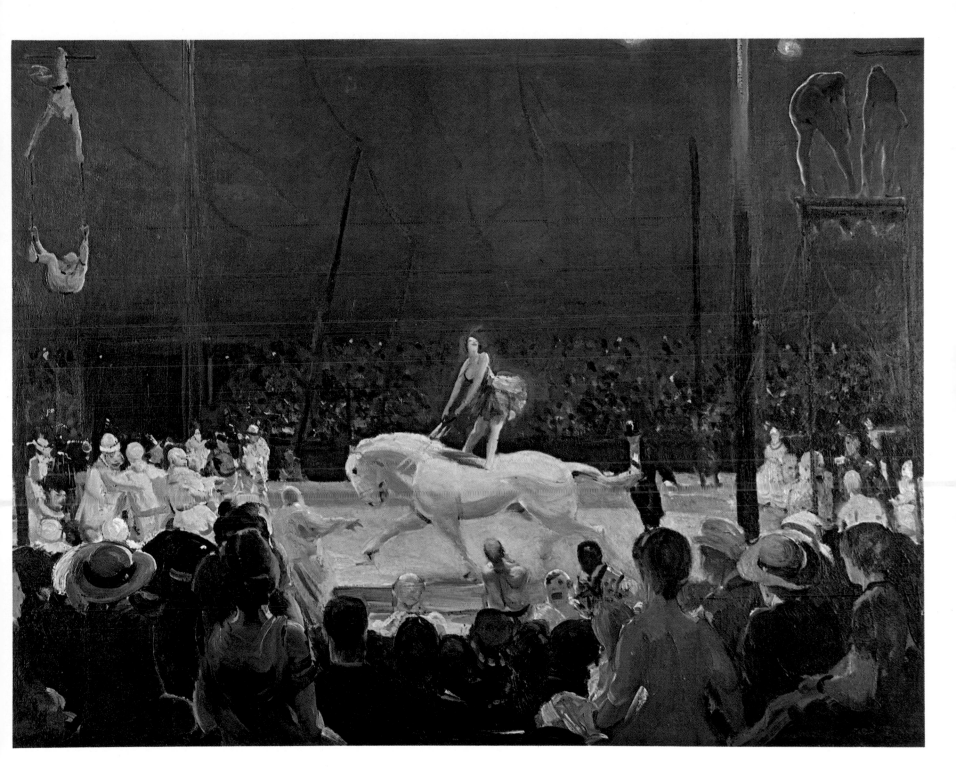

They will get that boat into the water. This sketch was painted very broadly and very fast, but there are dangers in this method. Bellows thought, and so did Rockwell Kent, another Henri pupil, that if you caught the big sweep you caught everything, but that is not completely true. The clouds have tremendous bounce, the headland juts out to sea, but the men are dummies stuffed in overalls. It is not enough to take care of the big picture; the rest will not necessarily take care of itself. Men against the sea are not always making heroic gestures; often they are doing niggly, human things.

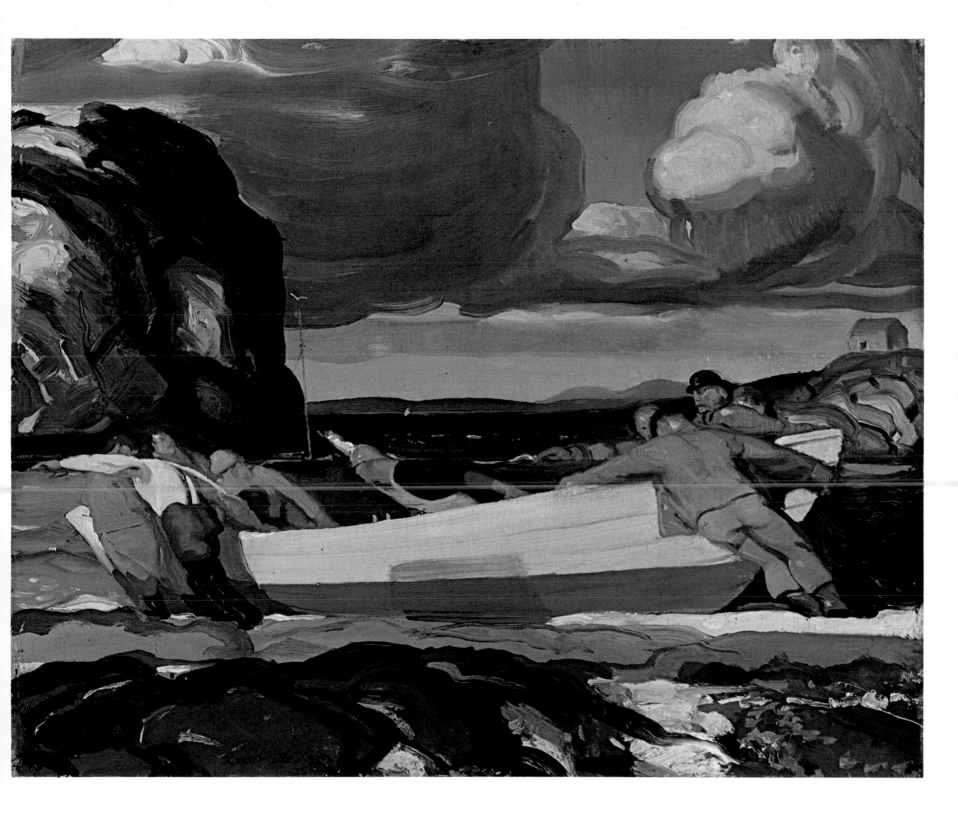

Plate 26
AT THE DOCK
1913
15" x 19½"
Oil on Panel
Joseph Davenport Collection
Courtesy of the Kennedy Galleries, Inc., New York, New York

Bellows had a fine feeling for salt water and messing around boats. You can smell it. He had a great ability to paint places he had never seen before, and he conveys the excitement of discovery. Pictures like this are not as simple as they look. The pattern of dark and light is unusual. Bellows did much better with his horizontals and verticals when he was painting naturally rather than when he based his picture on a "root five triangle" from Hambidge's book on "Dynamic Symmetry." In his early days, Bellows could *see* pictures, which is a great deal better than making them up in accordance with a formula. In Bellows' time, writers on art like Roger Fry and Leo Stein thought that they could paint because they knew all about art, but there does not seem to be much connection. What they could not do is paint this picture of a boat at a dock; they could not reach life—and life is what Bellows' art is all about. But even a natural artist like Bellows runs into difficulties, and that is when he leans on the crutch of theory. Few artists have enough steam to last a lifetime. Most fall into formula. But you cannot paint people and bustle and boats and hurry and water and light from a book.

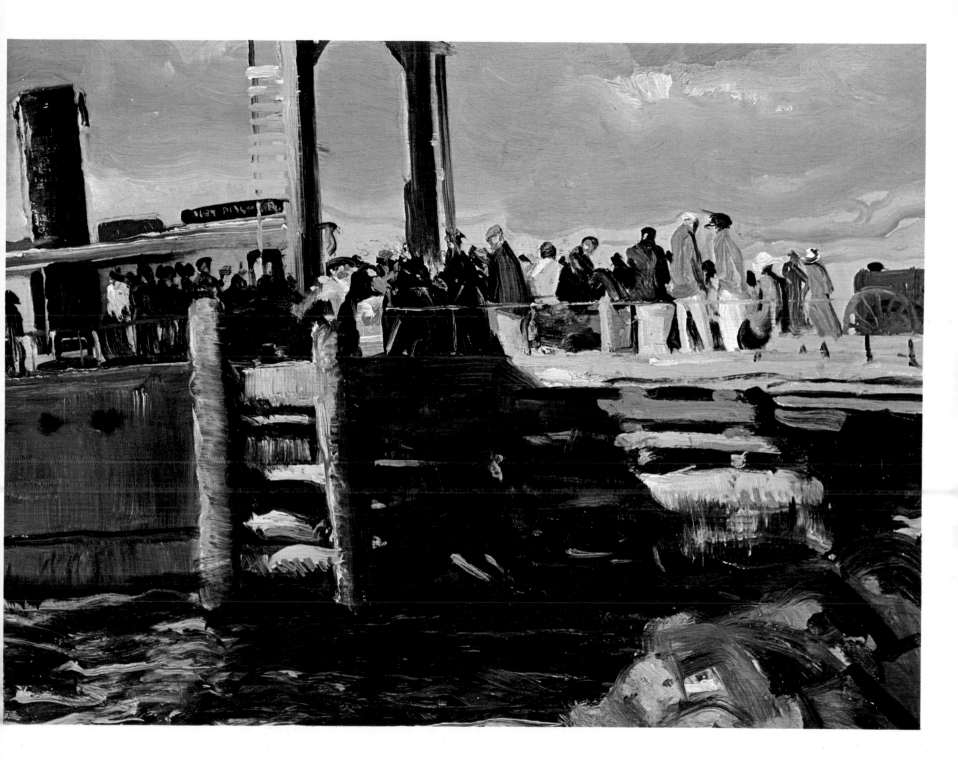

Plate 27

THE GRAY SEA

1913
12½" x 26"
Oil on Panel
Columbus Gallery of Fine Arts, Columbus, Ohio
Gift of Jesse Marsh Powell in memory of Edward Thompson Powell

This is a straight surf study, the sea breaking against the rocks. The title is not very apt, for the sea seething back on itself is green and white. In the great days of surf painters, when Paul Daugherty and Frederick Waugh were pounding them out, Bellows could paint the sea with the best of them. Before the subject went out of painting, it was one of the great ways to paint. The coast of Maine was one of his favorite stamping grounds and Bellows caught the surge and thunder very well.

Plate 28
CHURN AND BREAK
About 1913
18⅛" x 22⁸⁄₁₆"
Oil and Panel
Columbus Gallery of Fine Arts, Columbus, Ohio
Gift of Mrs. Edward Powell

This is part of Bellows' long love affair with Maine. Bellows was not one of the professional surf painters, men who followed the breakers to Cornwall and Brittany, but he could paint anything. Every man sees his own ocean, and Bellows loved the smash of the sea on the rocks.

Plate 29
WILLIAM OXLEY THOMPSON
About 1913
80" x 40"
Oil on Canvas
Mr. and Mrs. Donald B. Shackelford Collection, Columbus Ohio

Thompson was President of Ohio State University for years and he practically made the place. Bellows painted this portrait on speculation, but the University never bought it. Some people said it was too much like the old boy, and certainly it is the best of his professional portraits. Bellows made several other OSU portraits, including one of his great friend Professor Joe Taylor, who taught him how to read. He wrote to Taylor about this picture: "I am full of enthusiasm this night. . . . I looked at the Portrait two days ago and decided it was very punk.

"I have raised hell with it in the meantime and am sitting back now admiring myself, for she came through at last. I really think I've got a beauty, and I never worked so hard on a portrait in my life. It was a long series of experimenting to get everything to do its work with the rest. There is not a square inch that hasn't bothered me to death.

"I went at it yesterday and painted the whole thing over fresh. . . . I can now feel good about this work which has been challenging my ingenuity since I started it. There isn't a stunt I didn't try. . . . Every little part is now what I started out to get and the color of the whole is the richest thing yet."

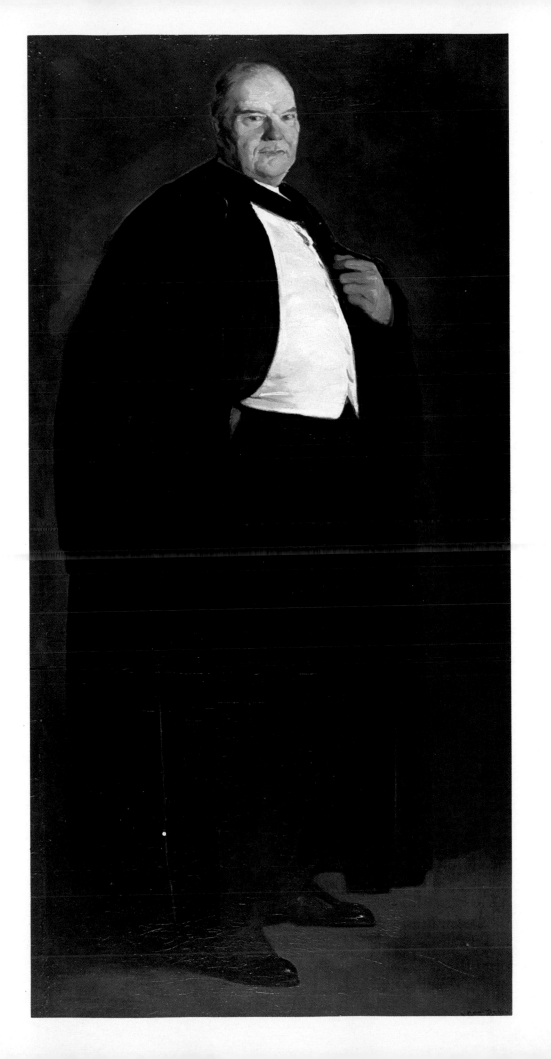

The portraits that Bellows painted in Columbus, where he knew the people, are much better than his New York work. Incidentally, Mrs. Arnold was not nearly this tall. She was quite a power in the art world of Columbus, one of the founders of The Columbus Gallery of Fine Arts and very prominent in its affairs. She knew Bellows well, and was a close friend of Emma. The black strings at the top of the bodice are up to Whistler, and Sargent would have approved of the way the arm is painted.

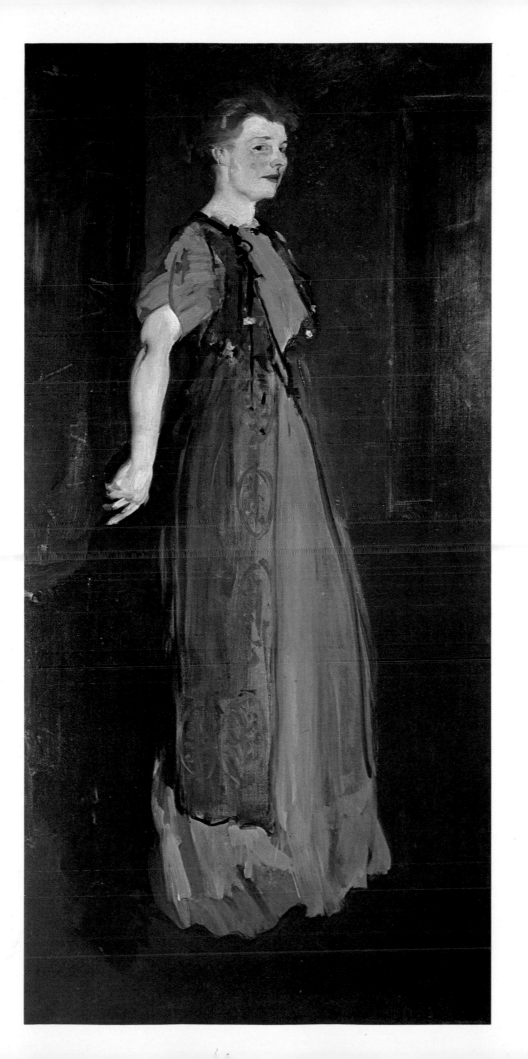

One of Bellows' drawings for *The Masses* was called "Why Don't They All Go to the Country for Vacation?" Here are forty-two kids spending the summer in the city, along with mama and papa and everybody else, trying to get a breath of air. Night won't be any better, and they'll try to sleep on the roof and on the fire escape. The big excitement will be when they open the fire hydrant. This was painted in 1913, fairly late for a cityscape as, after World War I, Bellows' heart was in the country. Bellows and his friends, Sloan, Luks, Glackens, and Shinn, were our first school of city painters, and the Fourteenth Street of Reginald Marsh, Kenneth Hayes Miller, and the Soyers grew right out of them.

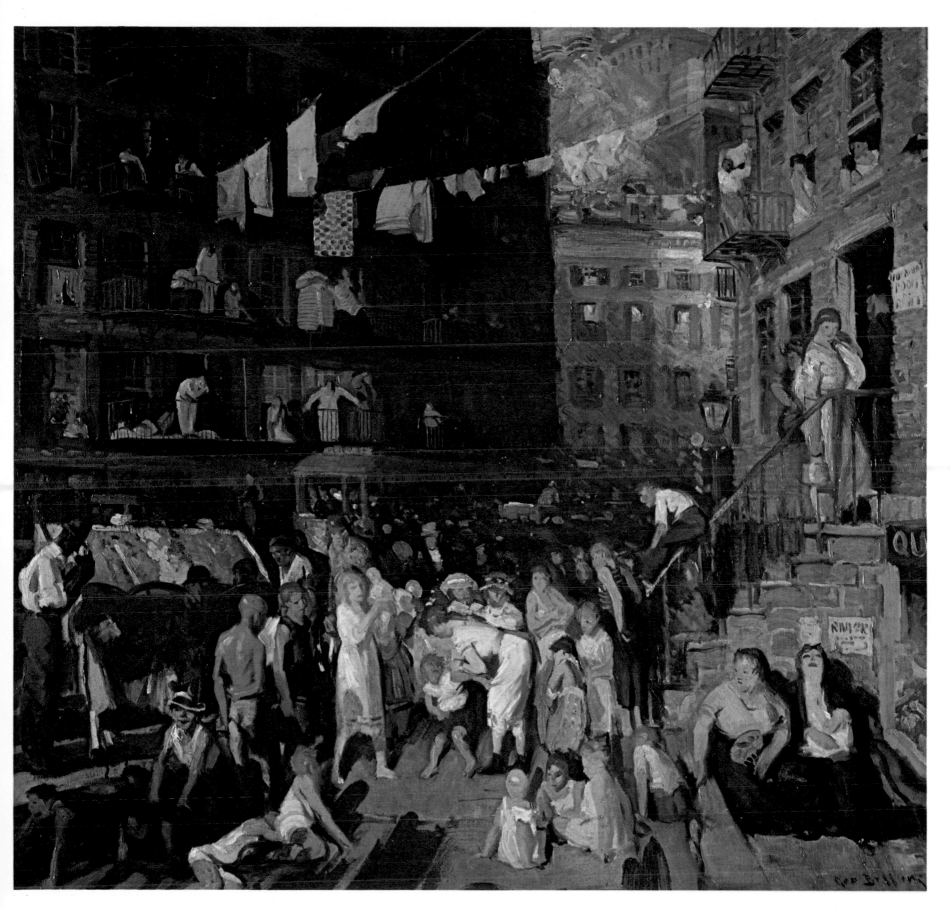

Plate 32

APPROACH TO THE BRIDGE AT NIGHT

1913
34" x 44"
Oil on Canvas
Hirschl & Adler Galleries, New York, New York

This was painted in 1913, when the Manhattan Bridge was under construction. The unusual angle is from the platform of the Canal Street Station of the Third Avenue El, so Bellows must have used sketches. Thomas Wolfe would have liked this ode to night in the city, if he had ever bothered to look at pictures. Bellows conveys the power and roar of the city, doing for New York what Whistler did for London. The El is gone—which is no great loss —but the bridges, old and new, are among our finest works of art.

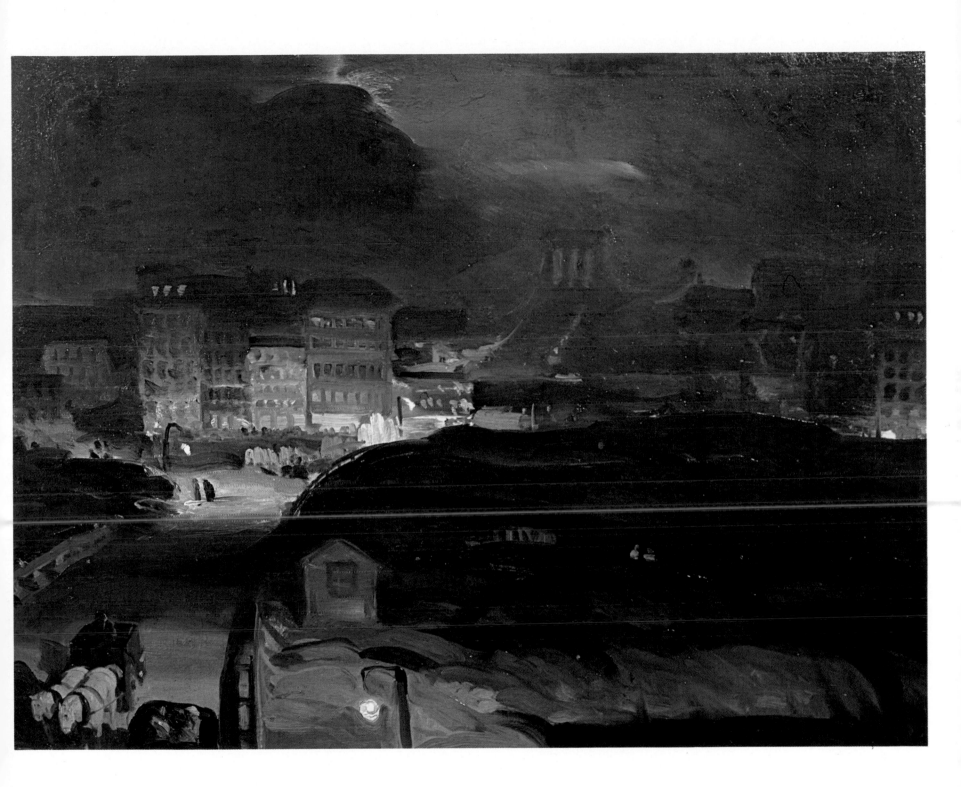

Bellows was very much interested in the craft of painting and he was strongly influenced by writers on the practice of his art. This portrait reflects the theories of people like Denman Ross, and was painted with almost the full spectrum, Geraldine Lee had an awkward grace which appealed to Bellows, and he had less trouble with this sitter than he did with Mrs. Chester Dale. Bellows was not cut out to be a society portrait painter.

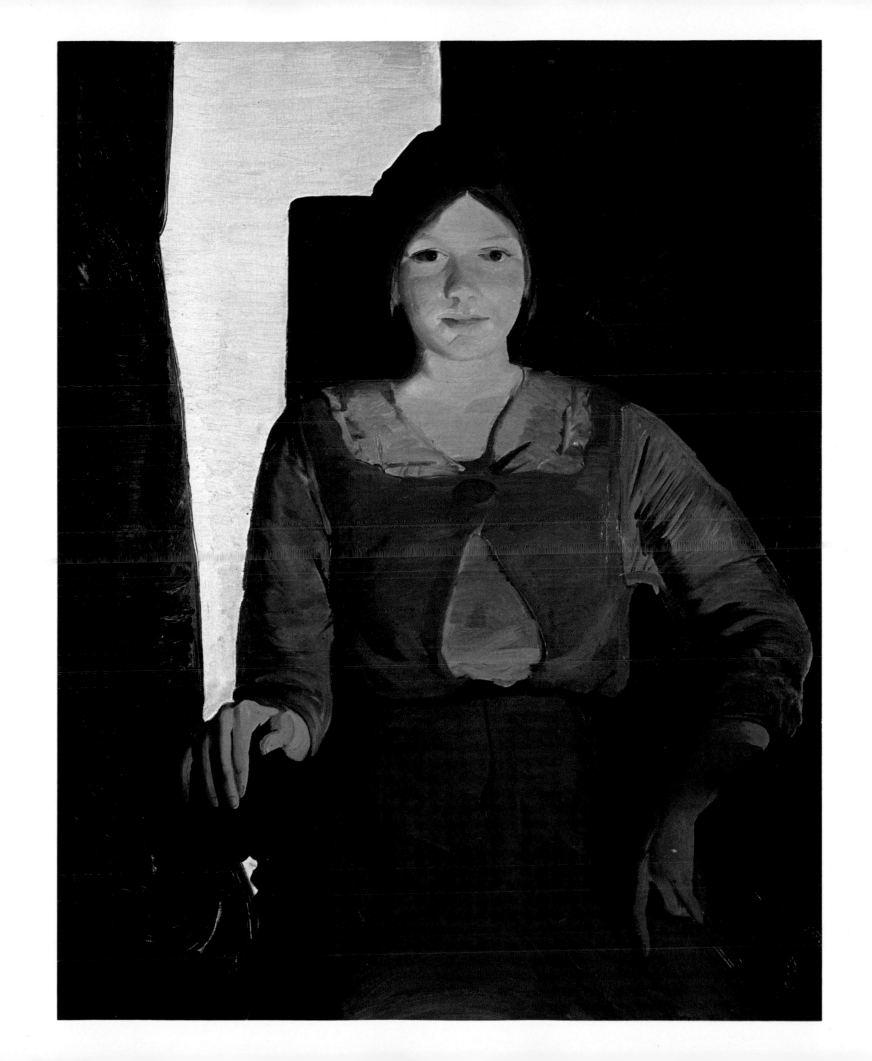

Plate 34

NUDE WITH PARROT

1915
40" x 32"
Oil on Canvas
Hirschl & Adler Galleries, New York, New York

Where did Bellows find a model like this in Maine in 1915? The girls follow the artists and Ogunquit was an artists' colony then as it is now. So far as is known, Bellows never glanced at another woman, except professionally, although he obviously liked them. Parrots must have been considered dashing as well as raucous birds, since they're often shown with nudes. Bellows painted two nudes that summer because there was so much fog, as there often is in Maine. Bellows had wanted to go to Monhegan again, but Emma wouldn't go because of the German submarines. There was a real spy mania along the Atlantic, much worse than in World War II, when the submarines were a lot closer. Bellows' mother came to visit them in Ogunquit, and she didn't think much of her son's nudes, as you can imagine. This painting was bought by Mrs. Harry Payne Whitney, who doesn't get enough credit for all she did for these artists. She actually did what Gertrude Stein is supposed to have done for the Cubists. The painting was later sold by the Whitney Museum, which was a mistake, as usual.

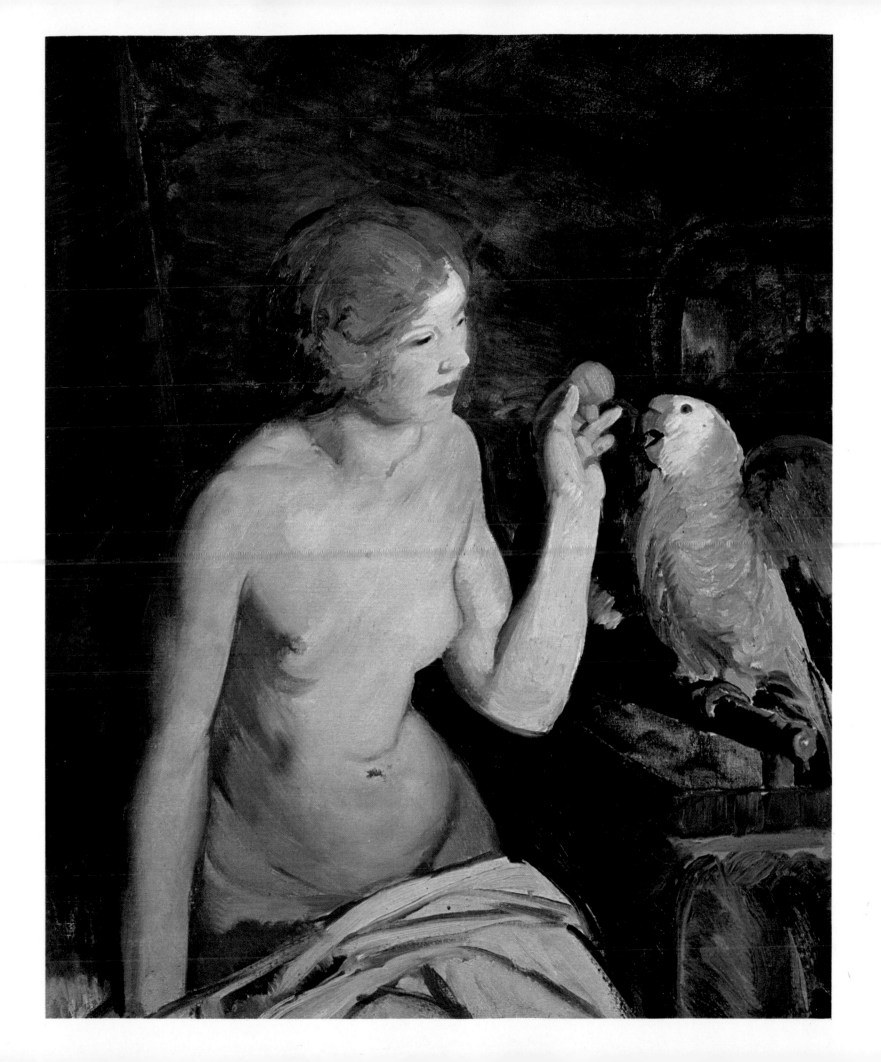

Plate 35

RIVERFRONT, NO. 1

1915
44¼" x 62"
Oil on Canvas
Columbus Gallery of Fine Arts, Columbus, Ohio

Swimming in the rivers around New York was great sport; you never knew what you'd swim into. It was still going on recently, and probably will next summer. There was no such word as pollution in those days, and this was good clean fun. You had to watch out, though, that you didn't get clonged by a piece of timber in the wake of the ferry, or some great Cunarder when it put out to sea. This was segregated swimming, of course, and there were no girls. Swimming off a pier is much more interesting than swimming at the beach or a pool: tugs and scows go by; you can jump off any place, and belly flop if you want. But it's not so easy to climb up on the dock again. Sometimes you have to dog paddle a long way to get to the wooden ladder, but that's easier than trying to shimmy up the cross-pieces. Nobody did the crawl then, but there were some pretty fancy high divers. There was a great air of high adventure about the whole thing. This is the daylight, city side of the old swimming hole, which many old timers will remember from their own boyhoods.

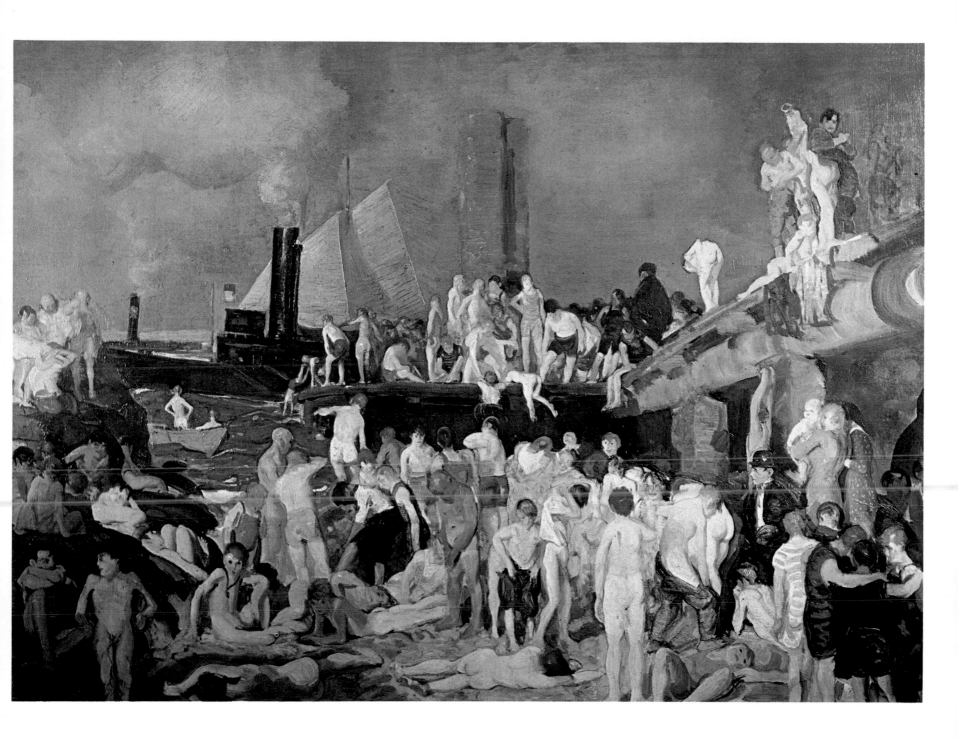

Plate 36
LUCIE
1916
23" x 18"
Oil on Canvas
Everett D. Reese Collection, Columbus, Ohio

Lucie Bayard was a young girl of sixteen, a protégé of Henri's, who brought her up to Ogunquit in the summer of 1915. Henri was not exactly pleased when Bellows took it in mind to paint this portrait. She was a very pretty girl, and there is reason to think that these two grown men fell rather in love with her. Certainly she was the cause of a certain amount of bad feeling between them, and she had the honor of causing the only rift there ever was in their lifetime friendship—Bellows didn't fall for a pretty face very often, but he did this time. Lucie became quite a good painter in her own right, as she should have with such teachers.

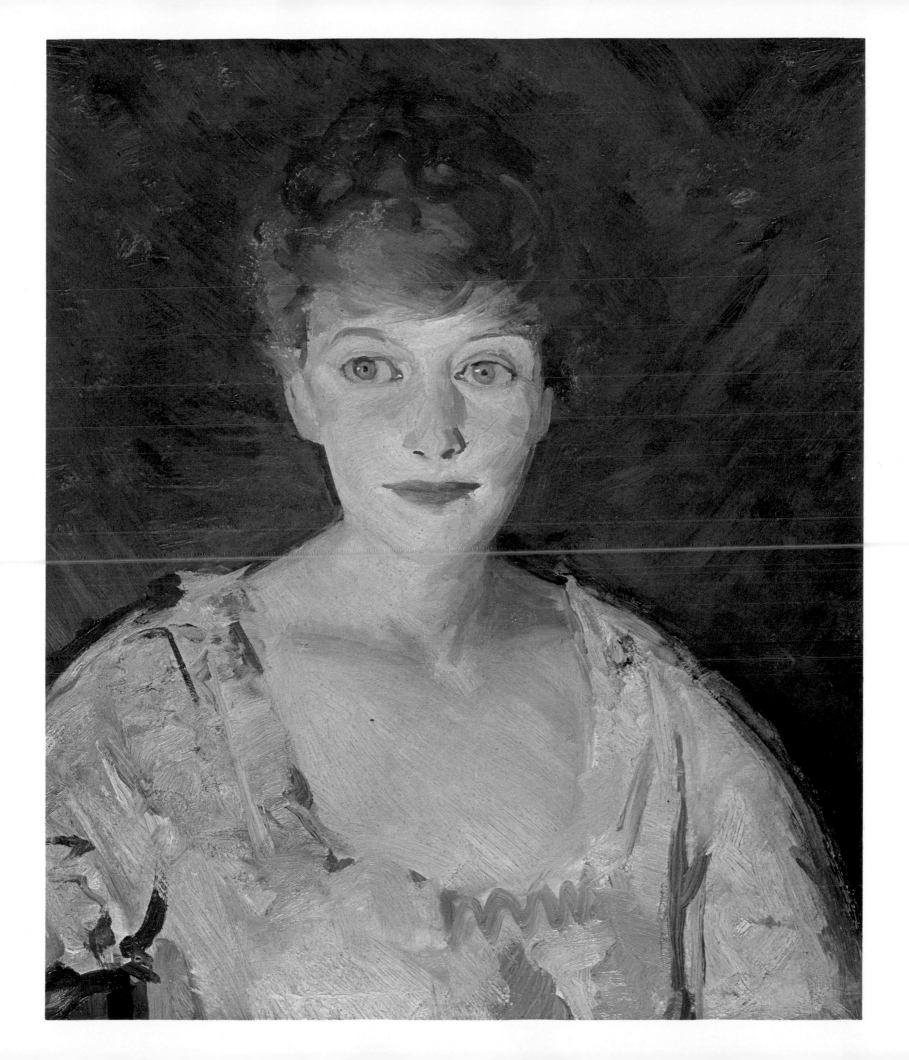

Plate 37
RAINY NIGHT
1916
22¼" x 28"
Oil on Canvas
Museum of Fine Arts, Boston, Massachusetts
Charles Henry Hayden Fund

Bellows could give the best side of a rainy night, the fresh smell, the interesting and baffling reflections, the whole vast and amazing phenomenon. Whistler had painted his nocturnes, but he concentrated on the poetry and the mystery. Bellows was more interested in the spectacle, and did not enter into the mood of things; he was an outside man who brought his own positive mood with him. There's something enjoyable about a rainy night, if you can get yourself in the right frame of mind.

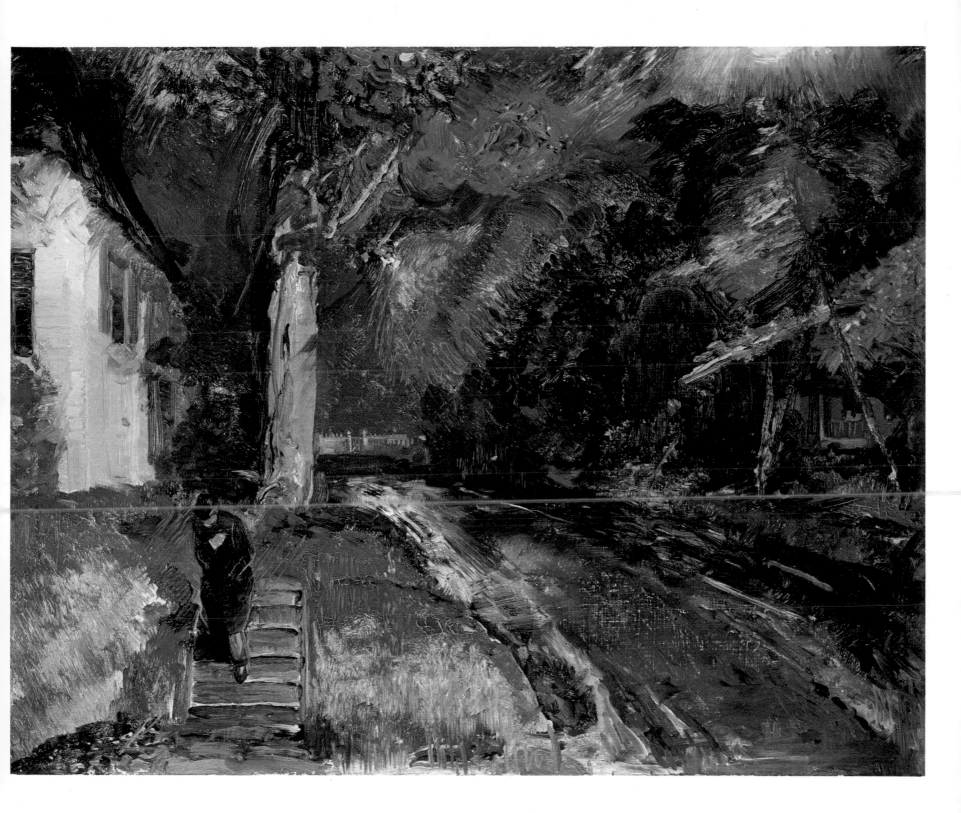

Plate 38

THE DOCK BUILDERS
1916
30" x 38"
Oil on Canvas
Hirschl & Adler Galleries, New York, New York

Building docks was miserable work; there was no way to keep from getting wet. Bellows liked this kind of drama, men against the sea, probably more than the men did. He admired lobstermen and shipbuilders, trades we've forgotten about. He shared this subject matter with Gifford Beal and Rockwell Kent. They all simplified the figures and kept the epic note, with a smart breeze blowing. Bellows was impressed by the Maine workmen, and he thought their work was fascinating.

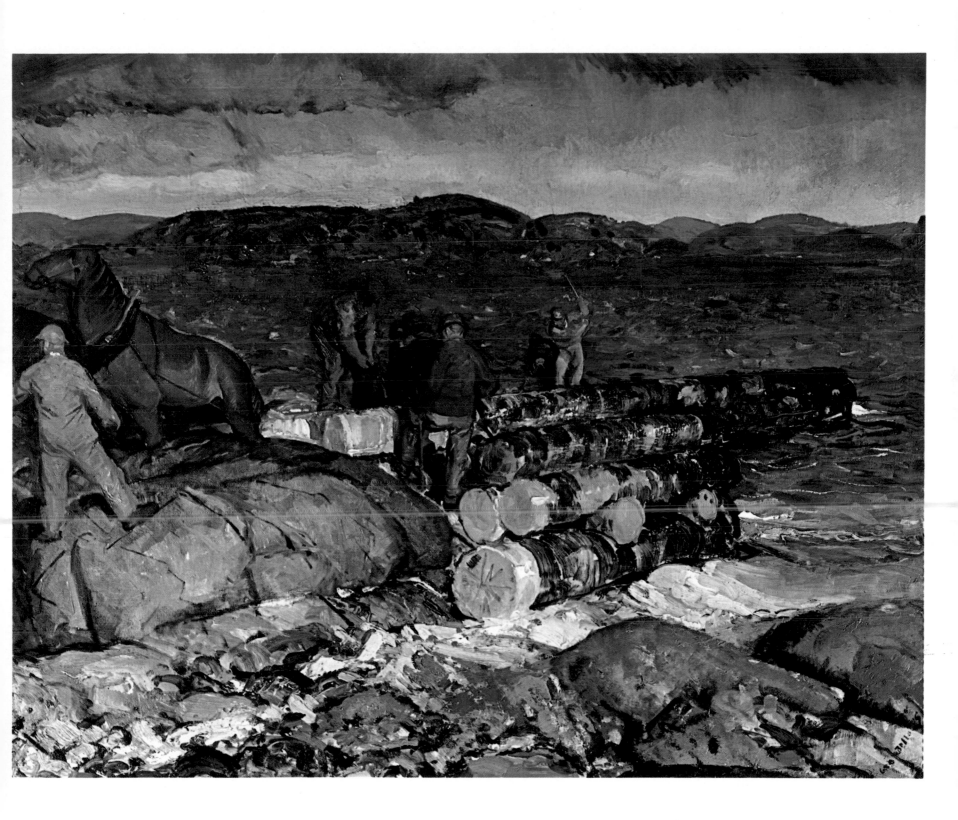

Plate 39

MATINICUS HARBOR, LATE AFTERNOON

1916
18" x 22"
Oil on Panel
Mr. and Mrs. Gerald B. Fenton Collection, Blacklick, Ohio

Bellows had visited this island off the coast of Maine, and was very much taken with it. It is just about as remote now as it was then. There is a boat three times a week, which brings over the mail and the groceries. Local residents still remember the painter. Matinicus and the other island, Monhegan, where many artists painted, were his favorite places in Maine.

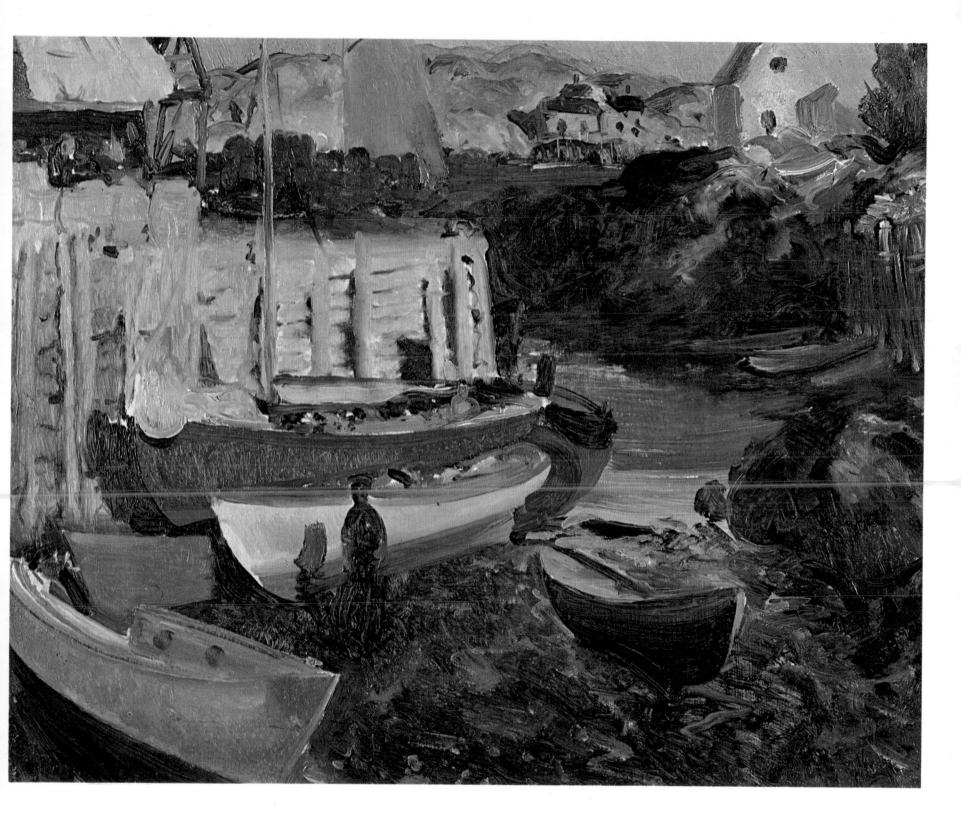

Plate 40

THE ROPE, OR BUILDER OF SHIPS

1916
30" x 44"
Oil on Canvas
Yale University Art Gallery, New Haven, Connecticut
Gift of Scroll and Key, 1929, in memory of Chauncey K. Hubbard

Ship-building was a wonderful occupation that went on all along the Maine coast. You could smell the oak. These ships were made with an adze, which turned out long coils of shavings like a plane. The men didn't need sandpaper; it was a one-tool job. The work was fascinating to watch, and it made far better compositions than Jay Hambidge's "Dynamic Symmetry." Bellows painted four ship-building pictures. "When I paint the beginning of a ship at Camden, I feel the reverence the ship builder has for his handiwork. . . . When I paint the colossal frame of the skeleton of his ship I want to put his wonder and his power into my canvas, and I love to do it." This is not exactly what the workmen thought they were doing.

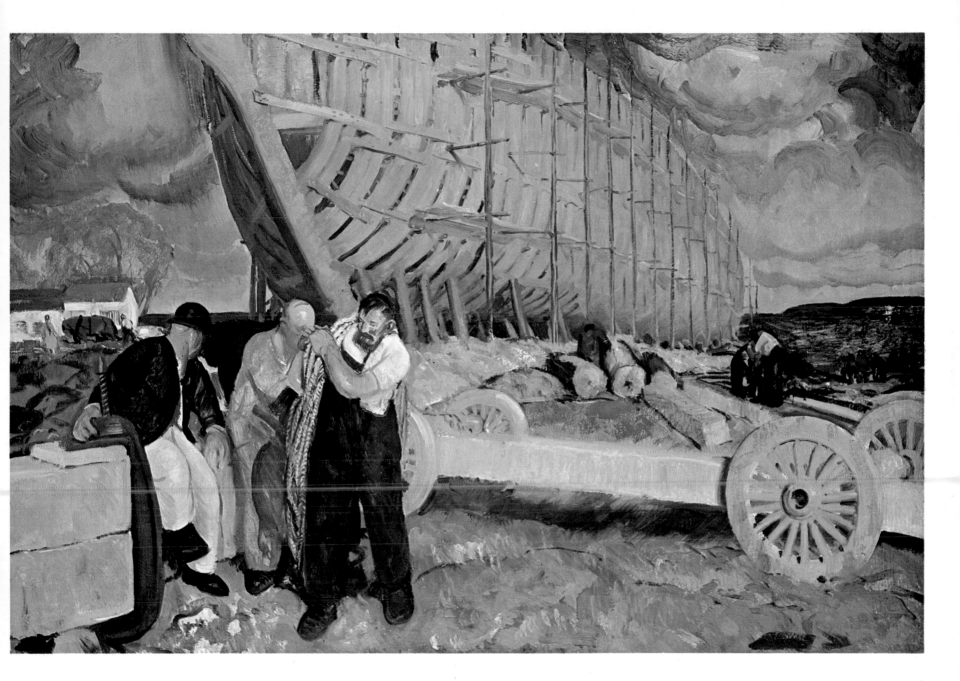

Plate 41
SAWDUST TRAIL
1916
63" x 45⅛"
Oil on Canvas
Milwaukee Art Center, Milwaukee, Wisconsin
Layton Art Gallery Collection

Bellows was great on the zip and color of American life, and this is one of his finest pictures. The whooping and hollering still goes on. The good old religion hasn't changed all that much. Our evangelists are scrubbed up a bit, but they're still doing business at the same old stand.

Bellows should have been more friendly to Billy Sunday, who started out as a professional baseball player. Like *Dempsey and Firpo, The Sawdust Trail* came out of an editor's assignment which sent him to Philadelphia with John Reed to cover Billy Sunday; "Christ for Philadelphia—Philadelphia for Christ." Bellows got pretty indignant about the whole thing, and wrote the editor of *Metropolitan Magazine:* "I like to paint Billy Sunday, not because I like him, but because I want to show the world what I think about him. . . . Billy Sunday is Prussianism personified." That was the worst thing he could say about anybody, but fortunately it did not affect his painting.

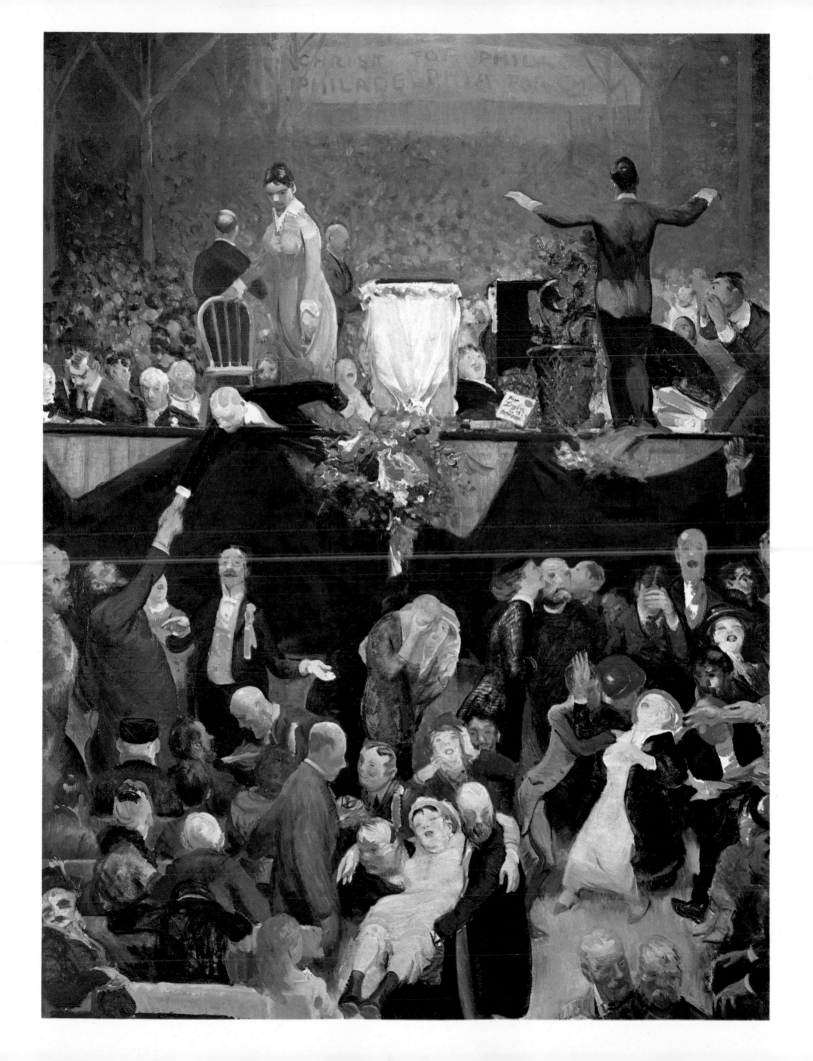

Plate 42

ROMANCE OF AUTUMN, SHERMAN'S
POINT

1916
22" x 18"
Oil on Panel
Columbus Gallery of Fine Arts, Columbus, Ohio
Ferdinand Howald Fund

For many of his later paintings Bellows, like Henri, used the colors recommended by Hardesty Maratta, a theorist of the time. Maybe they wanted to brighten their pictures, perhaps because of the Armory Show they felt they too should experiment and break out of their box. Everybody was experimenting with form and color then, and it was assumed that there was a scientific truth about form and color which could be found and taught. It would be terrible to think that art consists of arbitrary shapes and colors which please us at the time, and that by guess and by God is as close as you'll ever get. No one wants to admit that we don't know why we do what we do. That's why men buy theories. When the theories don't work, we say they were fools to try. Hardesty was not the answer, but we still want there to be an answer. What's an art school for? At first Henri taught his pupils, with all the force of his personality, to paint "like themselves." What does that mean? Well, it meant to paint like Henri and then go on. Bellows, and Henri, hated to stop there. The remarkable thing is that Maratta did not hurt their work very much. In this picture his colors are quite accurate—it's difficult to exaggerate the brilliance of an American autumn!

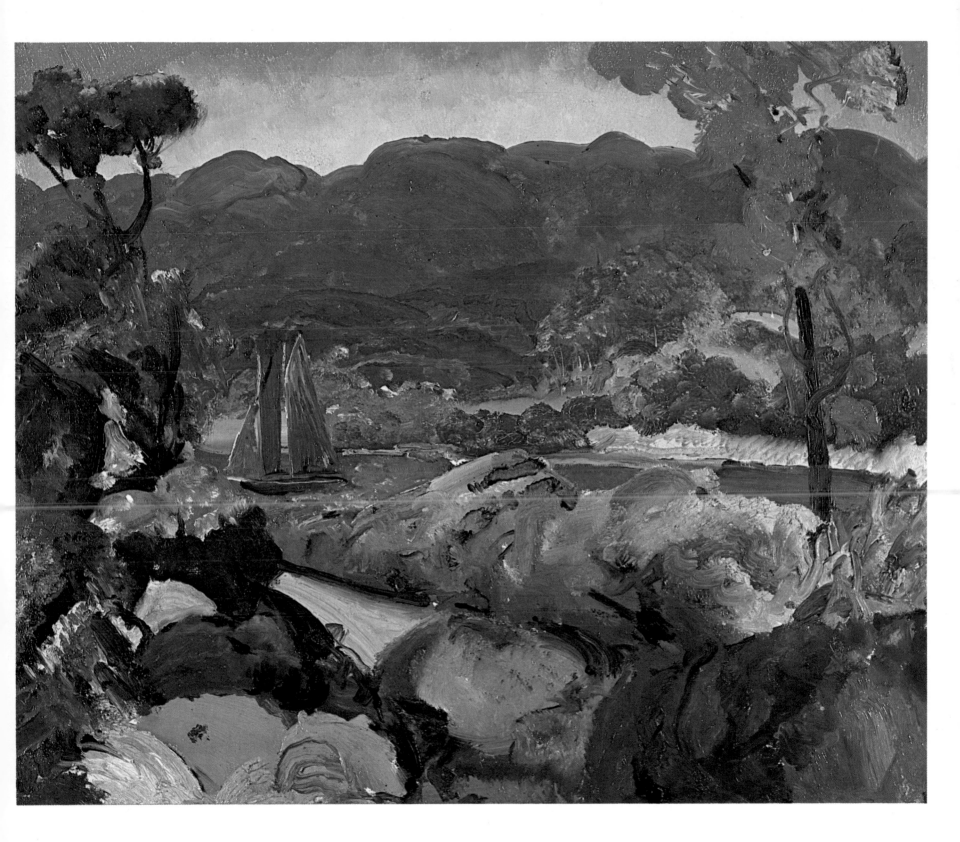

Plate 43

EMMA IN AN ORCHARD

1916
30" x 38"
Oil on Canvas
Hirsch & Adler Galleries, New York, New York

This looks like one of Manet's portraits of people in gardens, but we have so few gardens that Bellows called it an orchard. It's the same kind of picture, all right, with the same bench, the same sketchy foliage and clear color. It's Bellows' only outdoors portrait and one of his few Impressionist paintings. Henri's school of dark realists came *after* the American Impressionists, which reverses the European order. Emma is more relaxed and summery than usual. Bellows never thought very highly of French painters, and he got along without them very well. But this picture shows he could do what they did if he wanted to. Here he used Manet's light touch and light color, and there might have been more of these paintings if Bellows had gone to France, though he could see Manet at the Metropolitan just as well as he could in Paris. Bellows was not a museum man, as so many painters are: he painted from nature, or what he thought was nature, and he painted all the better for it.

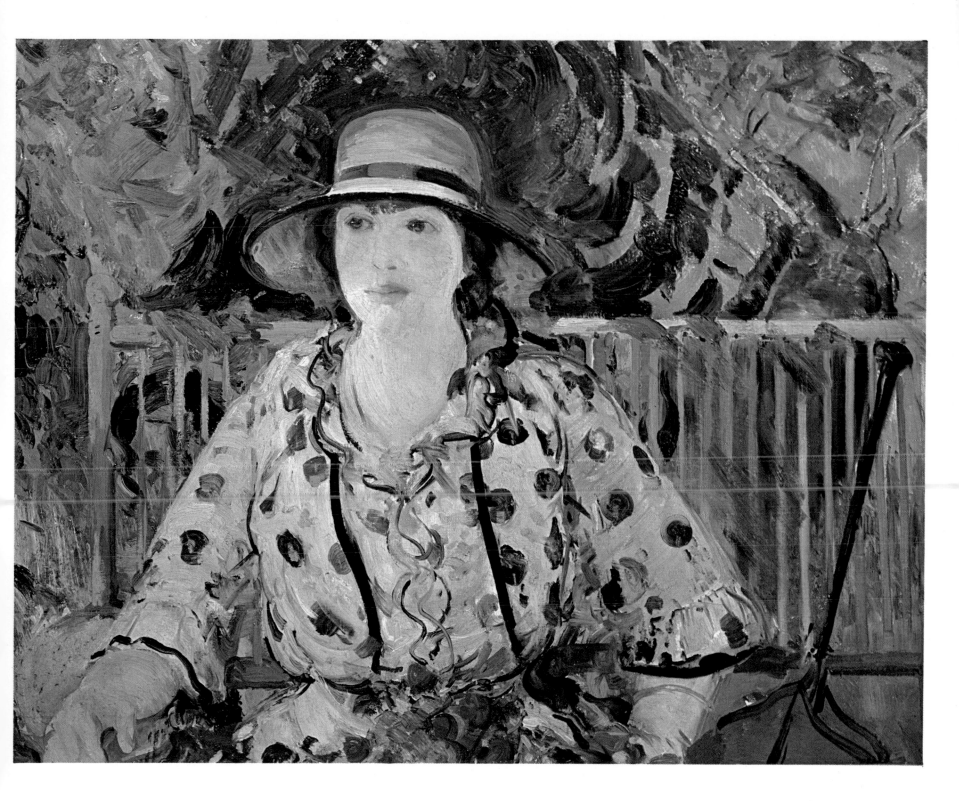

Bellows painted his daughters all over the map, and this one was painted in California. Nobody else has painted his daughters so often, a great series of growing girls. Bellows lived in a house full of females—even his mother was along on this trip. He was wildly enthusiastic about California, Emma less so. Traveling to the West Coast in a train was not nearly so wonderful as we make out. Bellows wisely let the ladies make the trip by themselves. If he felt like getting out of the house once in a while, you can't blame him. He rented a place in Carmel, and wrote to Henri: "This is an artists' colony, wonderfully ugly. Looks like a Methodist camp meeting ground (in spots). We have the 'Queen's Castle,' the most pretentious dwelling here with lots of rooms and a fine garden of flowers and trees looking out on the sea and almost on the beach." Actually, this fine portrait, with the full skirt and the white lace, could have been painted anywhere.

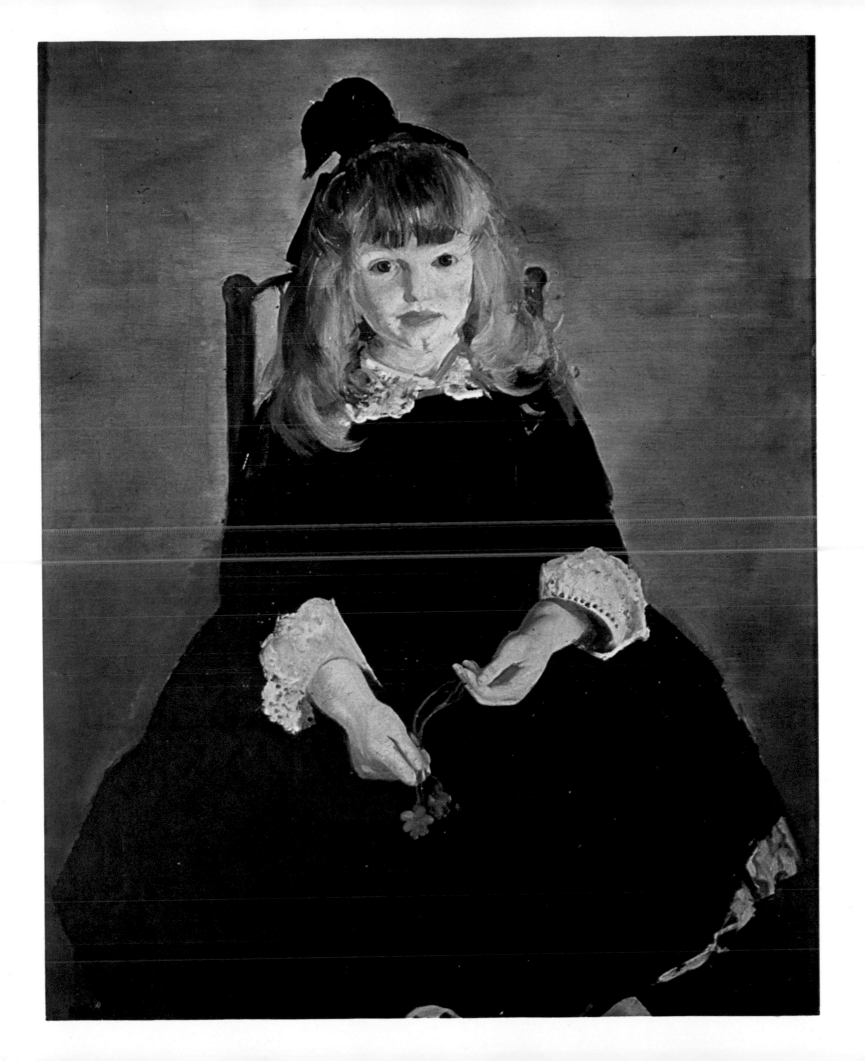

Plate 45

THE SAND TEAM

1917
32½" x 43⅞"
Oil on Canvas
Brooklyn Museum, Brooklyn, New York

This intentionally monumental picture is a success. Out in California, Bellows refused to be overcome by the immense scale of the Western landscape and this scene could perfectly well have been painted along the Hudson. It was the subject that interested him. Bellows wrote that he was "always very amused with people who talk about lack of subjects for painting. The great difficulty is that you cannot stop to sort them out enough. Wherever you go they are waiting for you." The country around Carmel is so spectacular that it's surprising he did not paint more of the steep slopes, the tall trees, and the hallucinatory coastline. Maybe he was afraid of being overwhelmed by it.

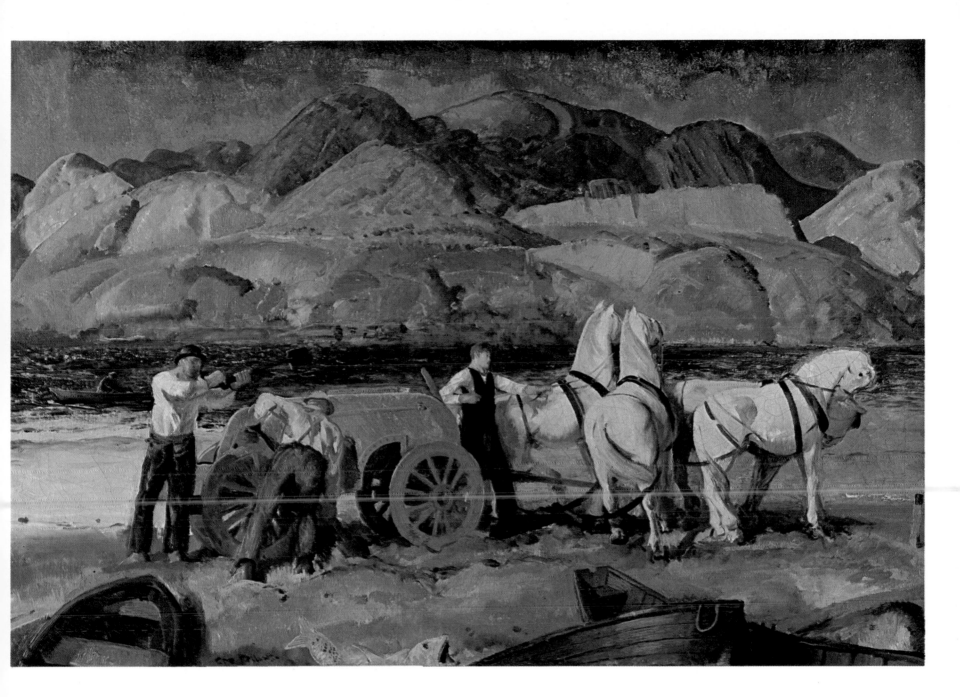

Plate 46

GOLF COURSE, CALIFORNIA

1917
30" x 38"
Oil on Canvas
Cincinnati Art Museum, Cincinnati, Ohio
In memory of Edwin and Virginia Irwin

The game here is not nearly as important as in most
sports pictures by Bellows. The California moun-
tains dominate the scene, and the figures are curi-
ously still, almost motionless. Probably golf did not
seem very exciting to him. For Bellows, as indeed
for many golfers, the sport consisted mainly of being
outdoors and wandering around in the scenery.

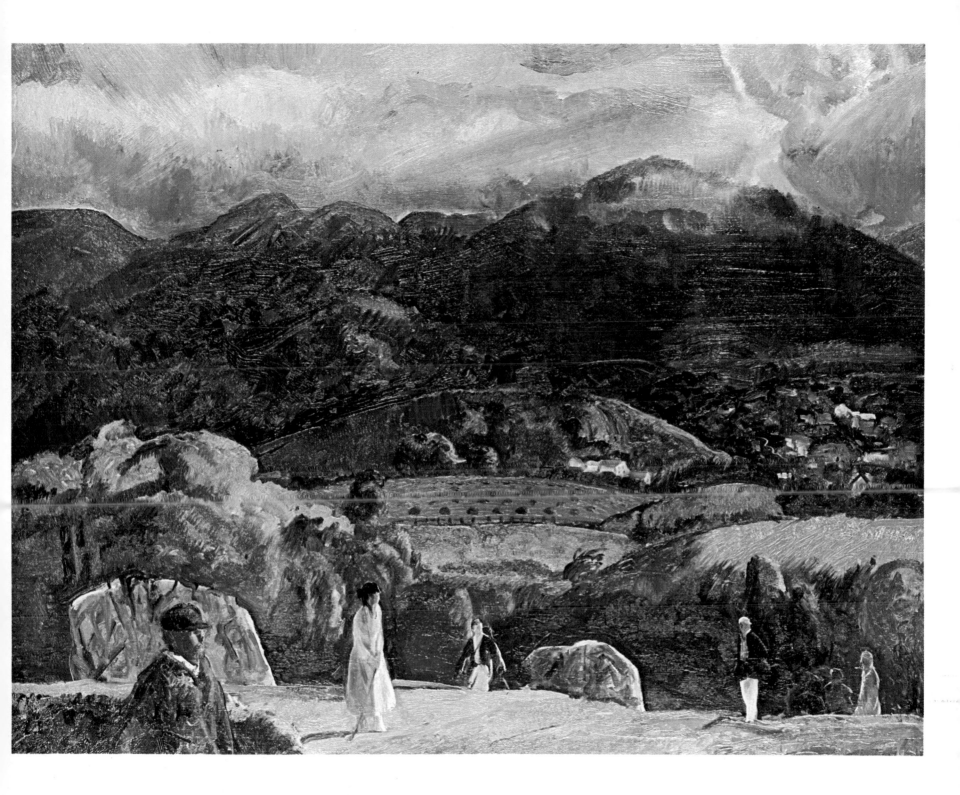

This is the first of two portraits of Mrs. Dale which Bellows painted in Middleton, Rhode Island, in July 1919. The other is in the National Gallery of Art, Washington. The Dales were dashing people with lots of money who cut quite a figure in the art world. Daniel Catton Rich does not believe that Bellows caught much of the mood of the Twenties and he contrasts Guy Pène du Bois' "little picture of Maud Chester Dale dining out in New York with Bellows' unsuccessful and somewhat 'official' portraits of the Dales." (Morgan, p. 141). Whether Bellows caught the spirit of the Twenties or not, the Dales did. They were "the rich," a separate clan as far as the artists were concerned, "Vanity Fair" people.

Bellows had a terrible time with these portraits. He began painting Mrs. Dale in her New York apartment, and he did not follow the method of Henri, who preferred to finish a picture in a day. Bellows painted for three months, a sure sign that things were not going well. Mrs. Dale wanted her dog in the picture, and she thought Bellows was "a bit vulgar, a bit too loud," which certainly did not help. Neither New York version was satisfactory.

When the Bellows family moved to Rhode Island for the summer, "Mrs. Dale, who has been facing me for two months from the model stand, has appeared on my trail in Newport." Perhaps because there was no dog this time, both new portraits pleased his patron.

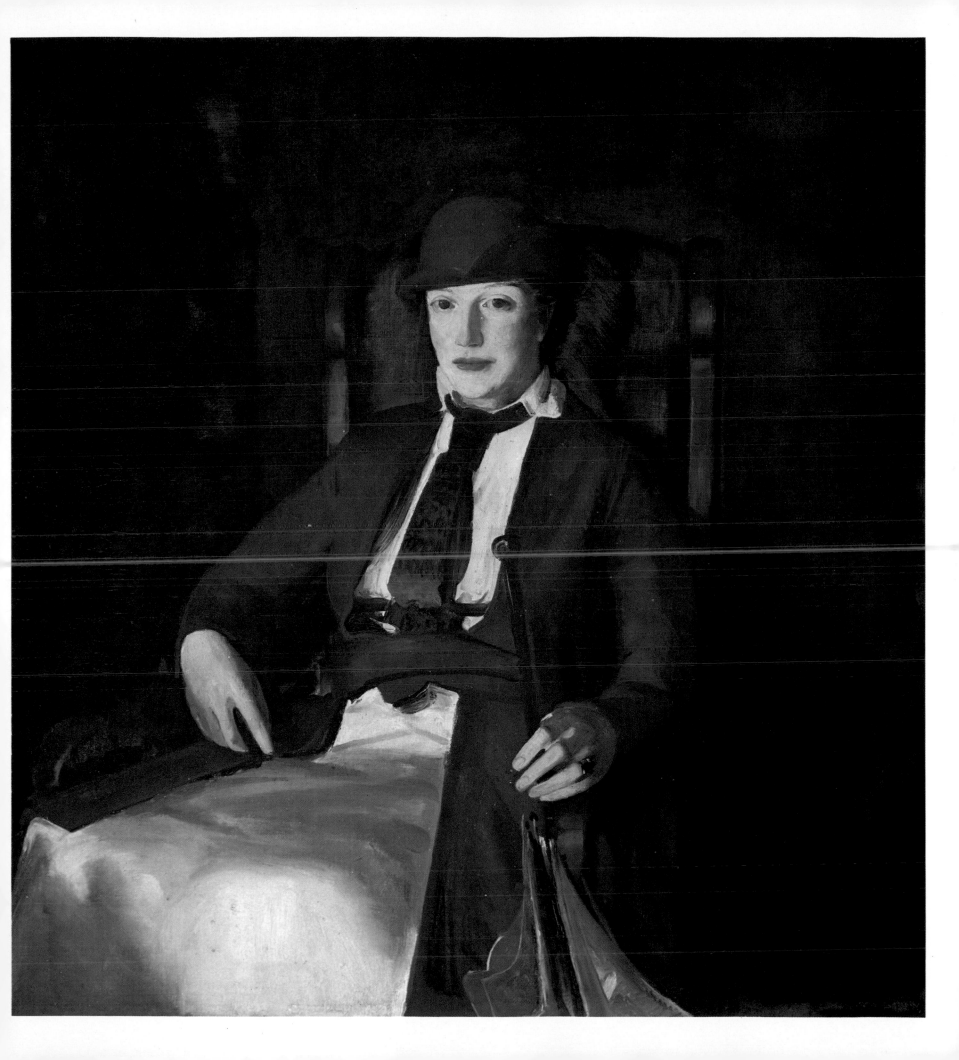

Bellows' daughters were his favorite models. Here Anne is standing on the left, with her doll, next to Jean, who is reading, and a friend of theirs, who was visiting them in their new house at Woodstock. It is a summer afternoon, and the sun is flooding onto the porch, It is a light-filled picture, high in key, and the colors are clear and convincing. On such a wonderful day, you wonder why the girls are hanging around the house. Maybe it's just after lunch, and Mother told them to. They won't be still very long.

There's a lot more framework to the picture than there usually is in Bellows. The heavy screens make a strong pattern. The roof, the pillars, and the window dominate the group of girls. He did not find this composition in any book of theory, he saw it. It's his only inside-outside picture, with the girls busy with their books on the dark, cool veranda, and the smash of sunshine outside. It is one of Bellows' most charming paintings. He was particularly good at capturing the awkward grace of young girls in their half make-believe world of childhood.

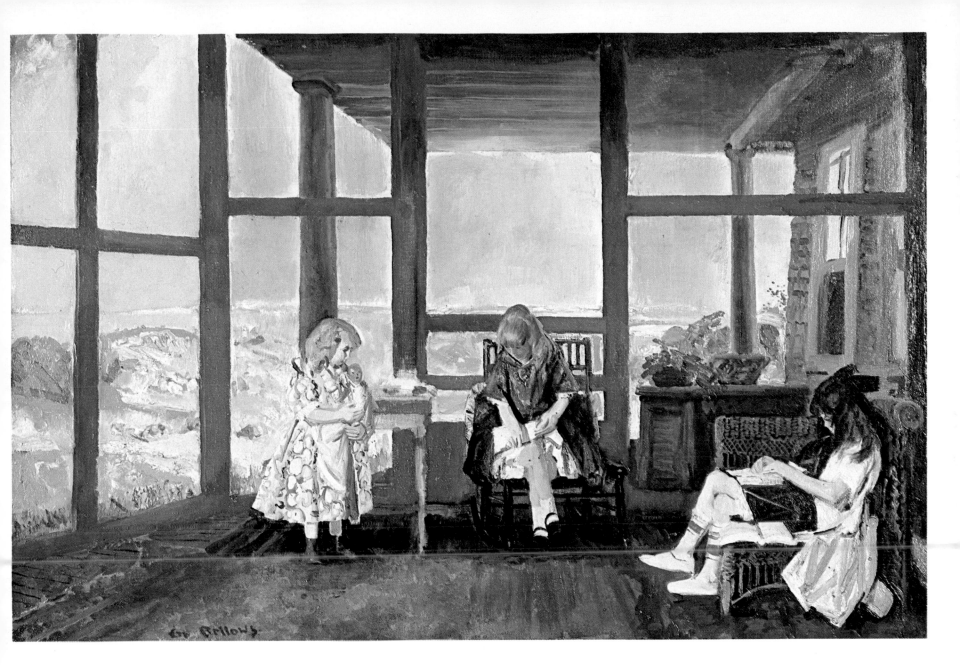

Plate 49
THE STUDIO
1919
48" x 38"
Oil on Canvas
Hirschl & Adler Galleries, New York, New York

The whole family loved their house on Nineteenth Street, and so they should. "The Block Beautiful" is a terrible name, but is not undeserved. Most city blocks look like other blocks, but this one has almost too much character and it has not changed a bit, with its odd jumble of buildings. They lived a good New York life there, about the best there is. People complained savagely about the city then, but for the well-off it was just as comfortable as it is today. Certainly they didn't want to live any other place. For an artist, there is no other place. And they had the best of it. A private house in New York is a luxury, and they were only a block from Gramercy Park, which still has its charm. For local noise and color, the Third Avenue El was just down at the end of the street, and Union Square was not far away. The family had a long run of luck, which lasted right up to Bellows' death. This is a kind of Velásquez picture with the artist at the easel, his bald head shining, Emma posing, as she so often did, the children on the floor near the Christmas tree and the doll's bed. Mrs. Story, Emma's mother, is telephoning at some length on the landing, with the black maid beside her. This is a picture of happiness.

The Bellows house is a beauty, plain and unadorned. You can't say that of all the houses in the block, some of which are gingerbread. All sorts of grand people lived there, like Bob Chanler, whose house was one long wild party, but the Bellowses were not party people, and George was never a drinking man.

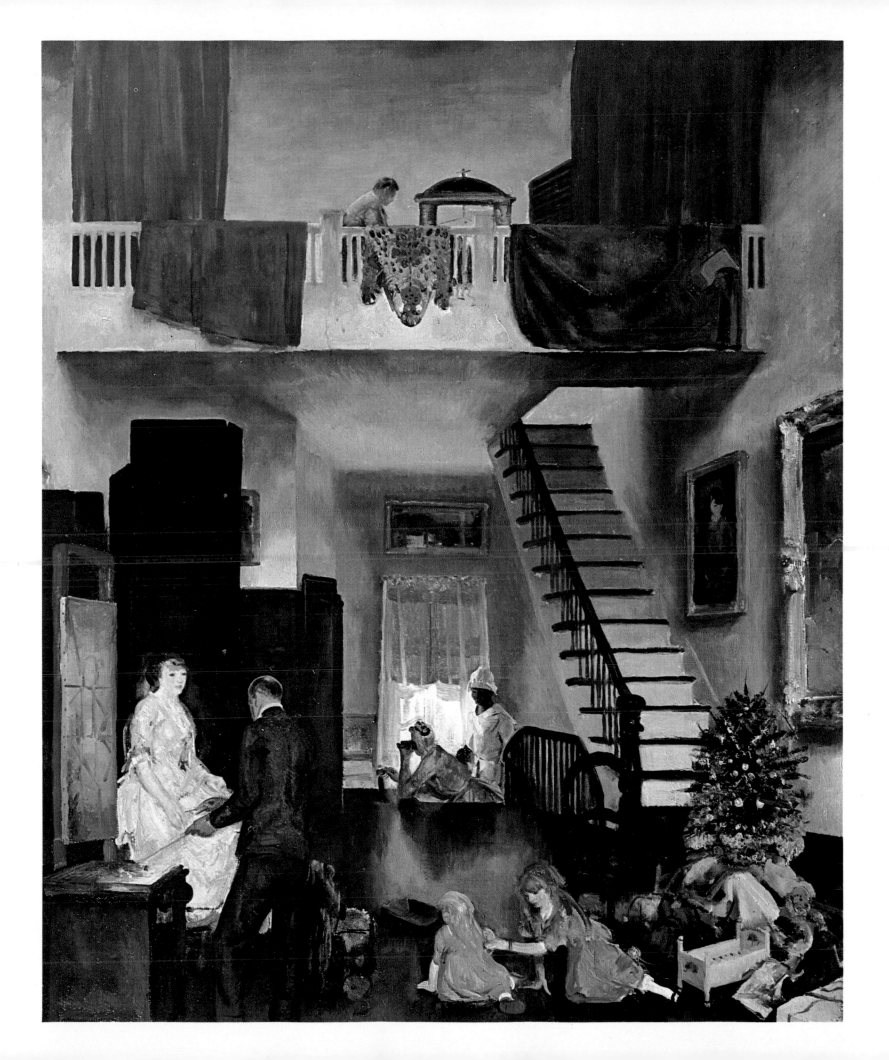

Plate 50
MRS. T IN CREAM SILK
1919
53" x 43"
Oil on Canvas
Joseph H. Hirschhorn Collection, Greenwich, Connecticut

Mrs. T. in Cream Silk shows the little old lady in the dress she was married in, in 1863. (The less finished original, with a red dress, is in Minneapolis). Bellows met Mrs. Mary Brown Tyler at a party in Chicago, where he was teaching, in 1919. They became great pals, and she was very proud of these pictures, although according to Charles Morgan, "Mrs. Tyler's relatives did not approve of them and insisted that they should not be associated with the family name." They consented to the Victorian anonymity of "Mrs. T." Bellows could do great things with people who interested him, and he was obviously taken with this one. We have forgotten all about little old ladies; they are an endangered species. But there were lots of them then, and they had a real tang of their own. They could say whatever they wanted, and usually did. They were independent characters, brave and fragile, and they did not take or talk any nonsense. They are gone now, along with old maids, who were often wonderful people too.

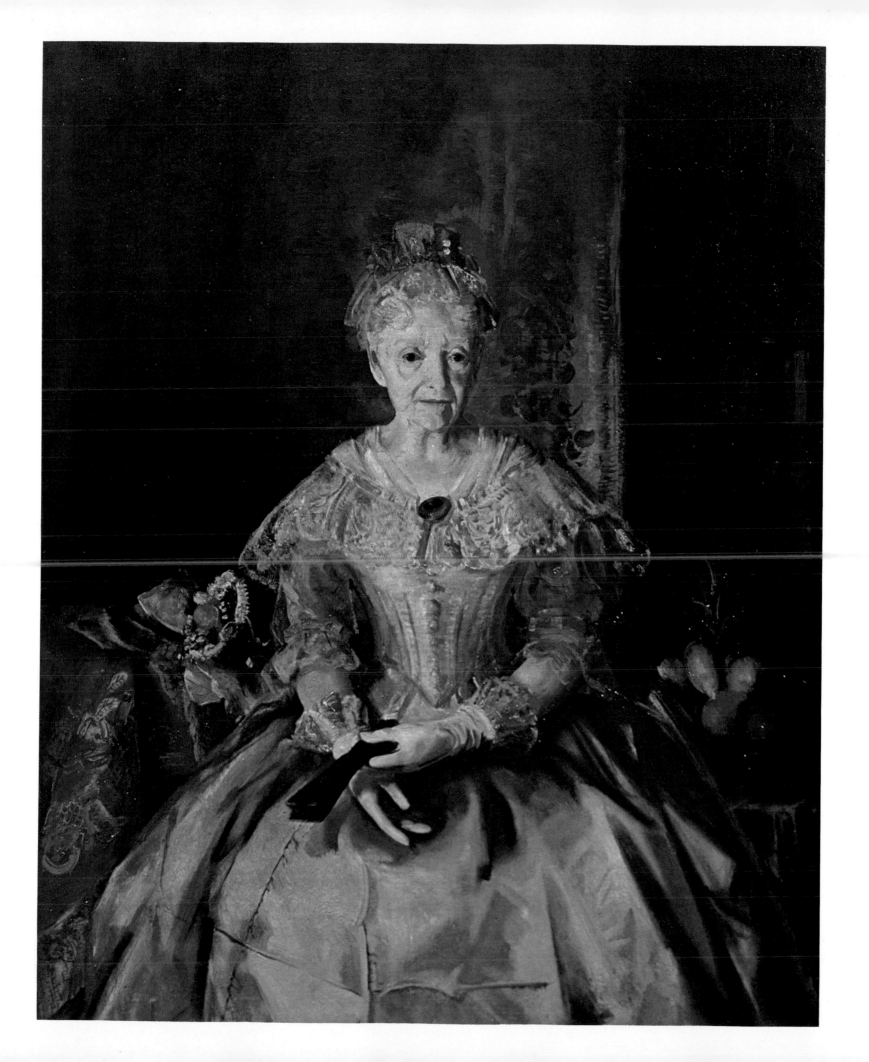

Plate 51
NUDE WITH FAN
1920
34" x 44"
Oil on Canvas
Hirschl & Adler Galleries, New York, New York

Bellows liked to paint big, handsome women, and he did very well by them. They are among his most finished pictures and he worked on them a lot. They have almost a mythological significance about them, though it's difficult to tell what it is. He didn't know, and he didn't bother his head about it. They came out very well. What's she doing with an ostrich fan in the middle of the afternoon? Posing for George Bellows, that's what she's doing.

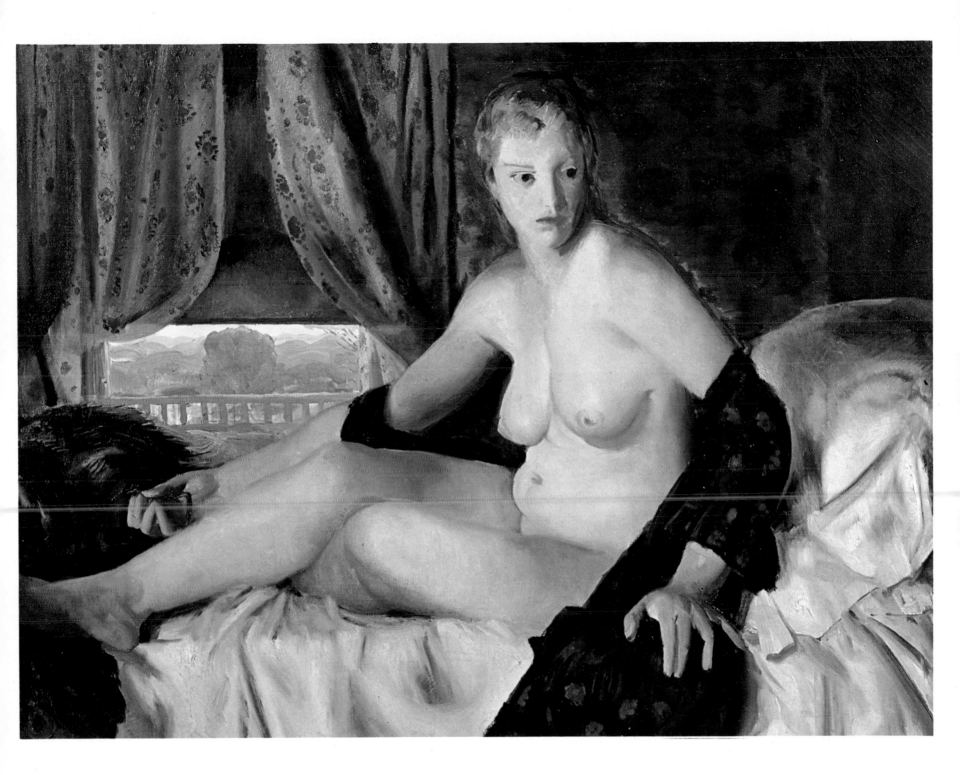

Plate 52

BARNYARD AND MOUNTAIN

1920
17" x 24"
Oil On Canvas
Newark Museum Association, Newark, New Jersey
Mrs. Felix Fuld Fund

Bellows thought pigs were funny, which is better than giving them all our vices. A farmyard to Bellows was more lyrical than it is to a farmer. He liked to poke around in odd corners, where the calves were. Maybe that's because he didn't have to think about the feed bills. He got along well with the farmers and with the animals too. For him, there was something irresistibly comic about three foolish pigs and a handsome and self-conscious mountain. It was part of his great good spirits; it was why he liked to sing and horse around. Oh, he had his low moments, but the prime mood that he expresses is exhilaration, in pigs, places, and people.

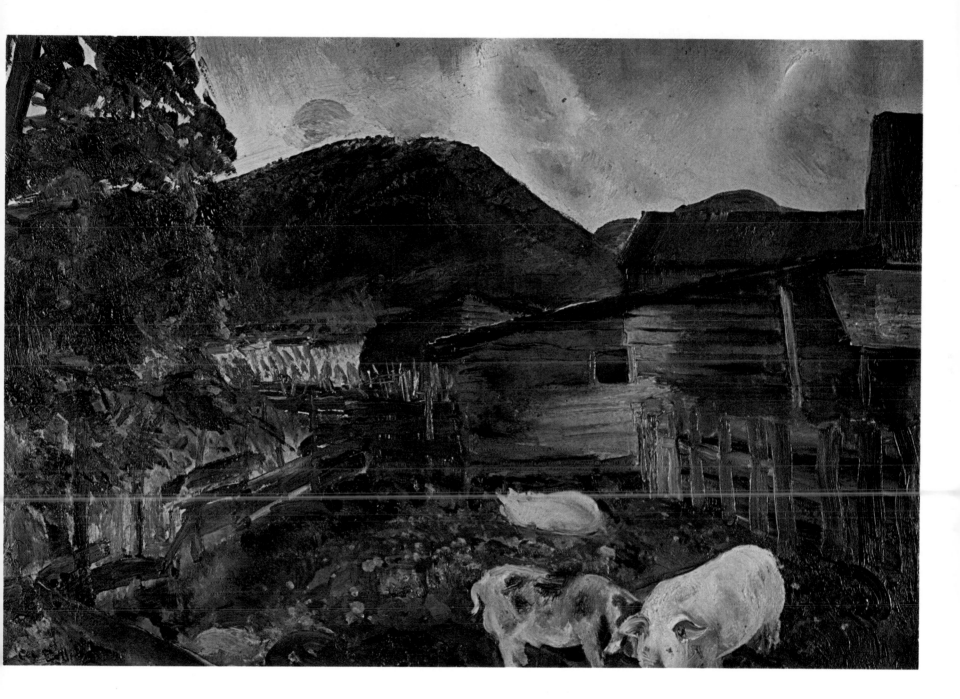

Plate 53

TENNIS AT NEWPORT

1920

57" x 63"

Oil on Canvas

Hirschl & Adler Galleries, New York, New York

You would think that Bellows would have been appalled by Newport, but he seems to have enjoyed it. It really is the land of the rich. Even today, there's nothing like the row of cottages along the sea, and the casino is right at the center of things. Maybe that's the impression Bellows wanted to give. He made a lithograph with the same title, but it's not at all the same. You'd think his friends at *The Masses,* where the artists were so much more important than the writers, would have kidded him about his adventures among the rich, but I guess you didn't kid George Bellows.

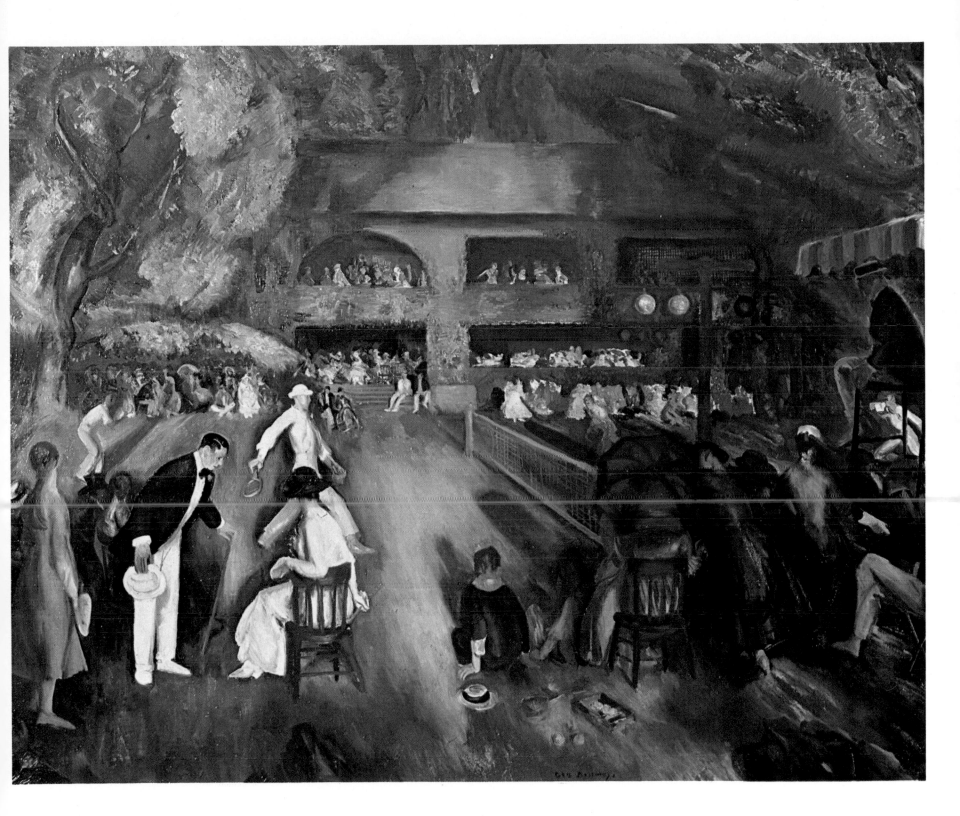

Plate 54
ANNE IN WHITE
1920
52⅞" x 42⅞"
Oil on Canvas
Carnegie Institute Museum of Art, Pittsburgh, Pennsylvania

This was painted at Woodstock, in the rented Shot-well house, in the splendidly productive summer of 1920. Woodstock was perfect for Bellows: the Speichers, the Krolls, the Rosens, and the Henris were often around, and there was even a baseball field, although this is not a necessity for most painters. Anne was the good child, the dreamy one, but he loved them both "best." They built their own house with a studio in 1921. Emma kept it all her life, and the girls sold it after her death. Rosen's house was across the brook. The painting was exhibited at the Ferargil Galleries, though the dealer he was closest to was Marie Sterner, who worked with Knoedler. *Anne in White* was not bought by the Carnegie Institute until 1925. Bellows knew the director, Homer St. Gaudens, the sculptor's son, very well, and Emma admired him very much. She always gave a party when he came to Woodstock on his selection tours.

Plate 55
NUDE WITH RED HAIR
1920
44⅛" x 34⅛"
Oil on Canvas
National Gallery of Art, Washington, D. C.

Painted from a model at Woodstock in 1920, this
picture belonged to Chester Dale, a great collector
of the day and a great backer of Bellows. Art his-
torians of the future would date this picture in the
Twenties by the bangs alone, although the beads and
the red hair are typical too. Bellows liked big girls,
and if they were not all that statuesque in real life
he made them so in paint.

Charles Rosen taught for years at the Columbus Art School, which was part of the Columbus Gallery of Fine Arts. Probably Bellows, who was a generous and helpful man, got him the job. After Bellows died, his great friend Speicher painted portraits in Columbus, probably again through Bellows' influence. Later, Rosen had a studio next door to Bellows in Woodstock, where Speicher lived too. Charles Morgan calls this painting by Bellows "the finest portrait of his life."

Plate 57

HUDSON AT SAUGERTIES

1920
16½" x 23¾"
Oil on Canvas
Columbus Gallery of Fine Arts, Columbus, Ohio
Ferdinand Howald Fund

You can see why Bellows liked the country. Large parts of the United States would be famous for their beauty if they were in Europe. The Hudson Valley is a classic place, with rolling hills, dark green trees, and beautiful white houses—no European country has so many white houses. Here Bellows could paint effortlessly and well. In painting, it doesn't matter how hard you try—it's how good you are that matters. Bellows didn't even need to go out of the house. This appears to have been painted from a second-story window, looking down on the cow below, perhaps because it was too hot to work under a tree. Nobody thinks of Bellows as a Hudson River painter, but he painted the valley better than most members of the Hudson River School. Here are two of Bellows' loves, the great river, so much more beautiful than the Rhine, and the countryside. Columbus was close to the country in his youth, and it is hard to believe that he did not occasionally think of Ohio when he painted New York State.

Plate 58
CORNFIELD AND HARVEST
1921
17¾" x 21¾"
Oil on Panel
Columbus Gallery of Fine Arts, Columbus, Ohio
Ferdinand Howald Fund

Bellows had to store up enough summer and sunshine to last all winter, when New York could be pretty grim, with the ash cans piled up on the cellar stairs. We forget what coal furnaces were like.

Cornfield and Harvest is the vision he kept all winter. His cornfield is lyrical; summer's lease is ending. Everything is golden, except the dark sky that gives the contrast in which he delighted. He caught a lot of these golden moments, more than most men, whether they paint or not. This is summer as it should be. Bellows spent a lot of time at Woodstock, the artist's colony in the Catskills, and he liked it so well that he built a house there. From these visits to this beautiful part of the world stemmed a series of his most pleasing landscapes.

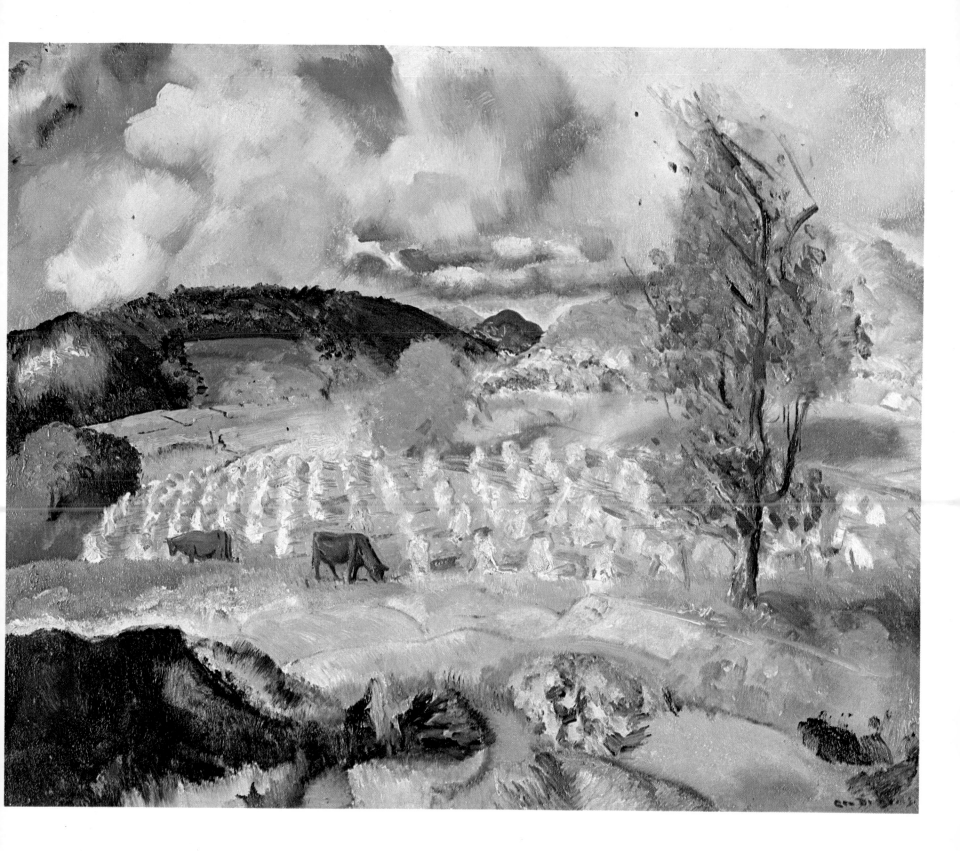

Plate 59

PORTRAIT OF MY MOTHER, NO. 1

1921
78½" x 48¼"
Oil on Canvas
Columbus Gallery of Fine Arts, Columbus, Ohio
Emma Bellows Collection

Bellows was no mama's boy, but he certainly was the apple of his mother's eye. Her husband was many years older, and she was completely wrapped up in George. Bellows was an only child, but at least he escaped the problem of having an older brother, or being the middle of five. She was proud of her boy, as she had every right to be, and he returned her love and affection all the days of his life. They got along wonderfully together, and she never made too many demands. He was the center of her life. Though she did not share his New York career, she must have thought about it a lot. And you can be sure that, since it was her boy, she thought it was wonderful.

This is very dark for a Bellows picture, but the world was darker in those days. Widows wore black dresses and sat on black horse-hair chairs. The wooden venetian blinds don't let in much light, which is quite right. It's a little hard to see where the brilliant light on her hands and face comes from. The hands are not very good; they look like claws. Maybe she had arthritis. Bellows was not very good on hands, but he was excellent on the black lace and the black silk, and the weighty way she sat there.

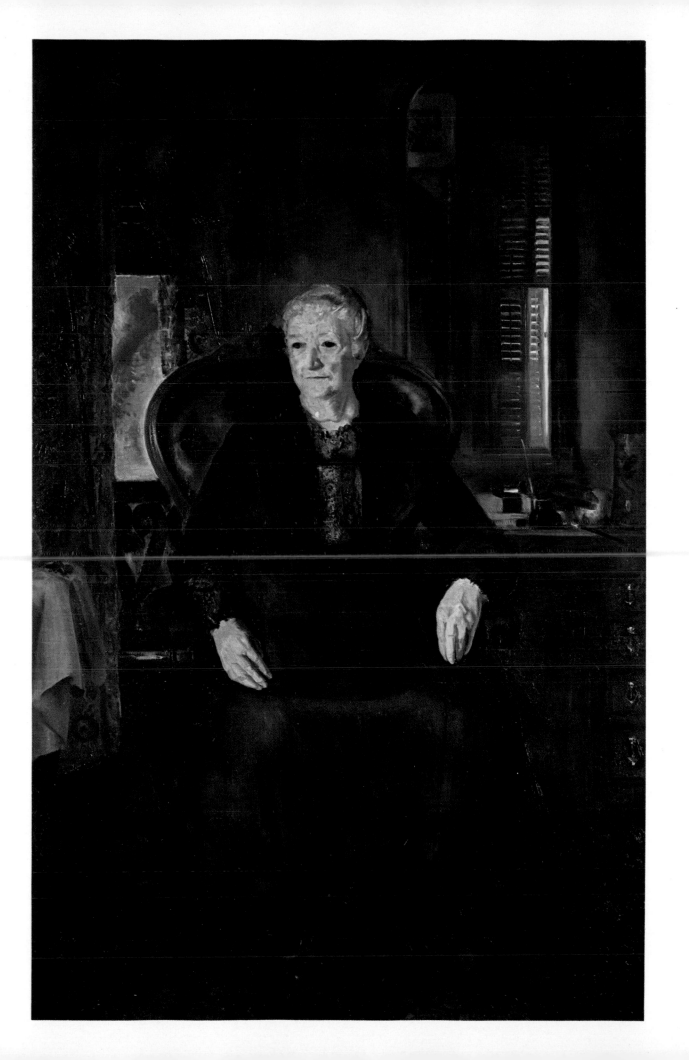

Plate 60
THE WHITE HORSE
1922
34⅛" x 44¹/₁₆"
Oil on Canvas
Worcester Art Museum, Worcester, Massachusetts

Usually Bellows is a realist, but this is no ordinary farmyard scene. It is touched with magic. *The White Horse* is a poetic symbol of an intensity that Bellows rarely attained and probably rarely wanted to. In his later work, the poetry was gaining on him. When the angles don't seem right, it may be the result of Jay Hambidge's "Dynamic Symmetry."

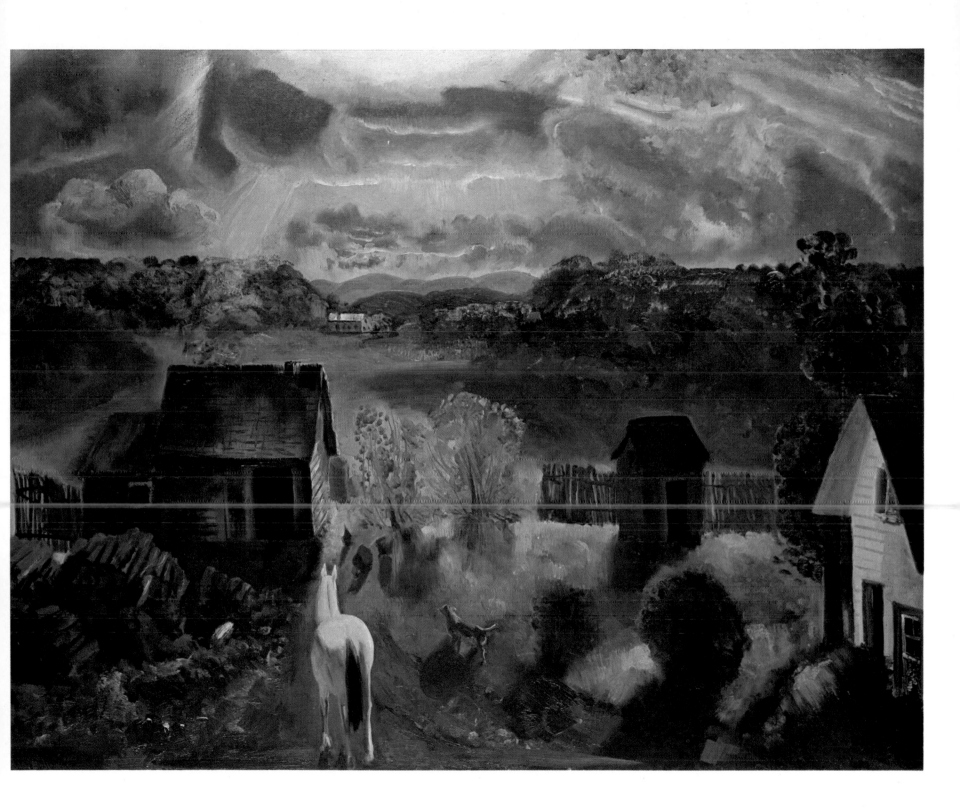

Plate 61
RINGSIDE SEATS
1924
59" x 65"
Oil on Canvas
Joseph H. Hirshhorn Collection, Greenwich, Connecticut

This is a late Bellows, and a good one, of the old Madison Square Garden, Stanford White's pleasure dome. The fighter is being introduced. What voices the announcers had, particularly Joe Humphreys! In forty minutes, the fighters won't look that good. The truncated cone of light is marvelously full of smoke. The sports writers are down front, and then the ringside seats, with the sporting gents and the women, who screamed louder than anybody else. Bellows was repelled by the fights, but they fascinated him. This is less dramatic, less forced than his other fight pictures. You can smell the sweat, the same way you can smell a bull fight. The crowds, including the women, love blood: that's what they come for and that's what they get. They aren't interested in the manly art of self-defense any more than racing fans are interested in the breed of horseflesh.

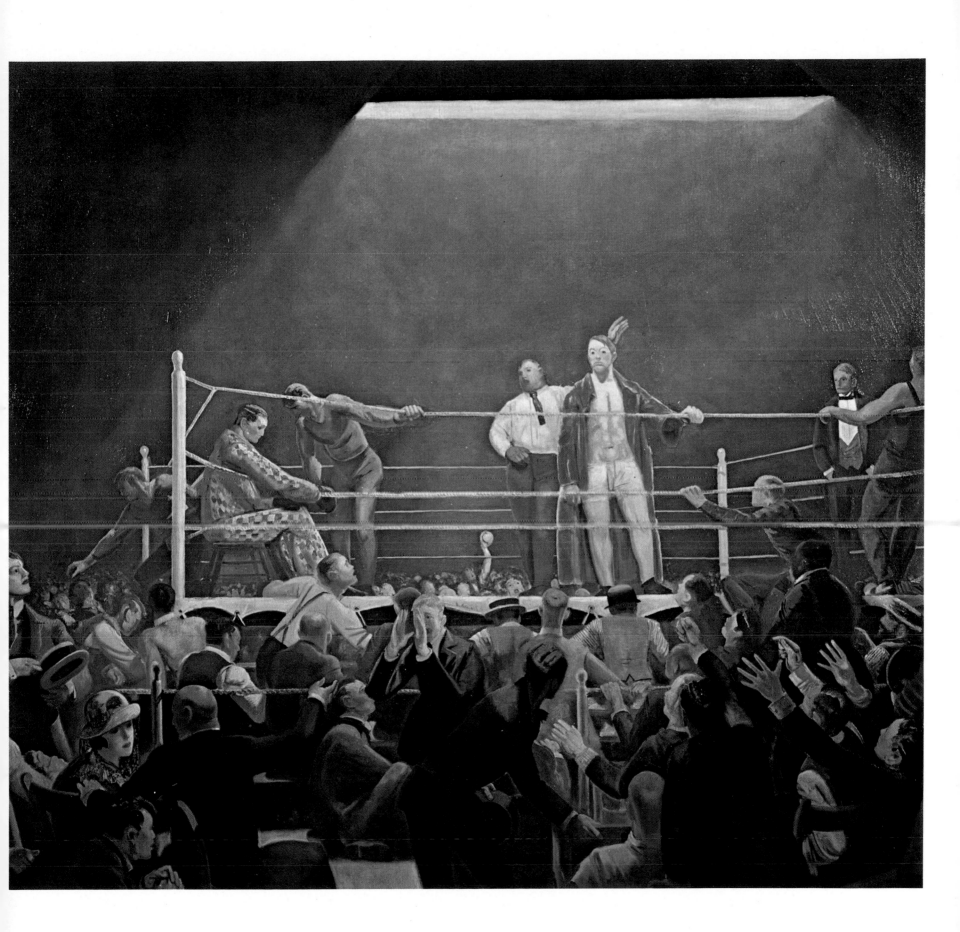

This is one of Bellows' most famous paintings, but not one of his best. It's way out of drawing, the figures are unconvincing, the colors are ghastly green. The two men in the foreground don't even look surprised when Dempsey falls in their laps. The referee is unreal. The grommets and the lacings on the canvas are far too precise. Yet there's a grand heavyweight crash and bang about it. You aren't supposed to look too closely, just take in the sweep of the arm and the fall of the man through the ropes. In Bellows' last years, while his compositions became more monumental, life, precious life, was passing out of his figures. Bellows saw this fight at the Polo Grounds, and wrote to Henri: "When Dempsey was knocked through the ropes he fell in my lap. I cursed him a bit and placed him back in the ring with instructions to be of good cheer." This fight gave rise to a tremendous amount of argument as to who really won it.

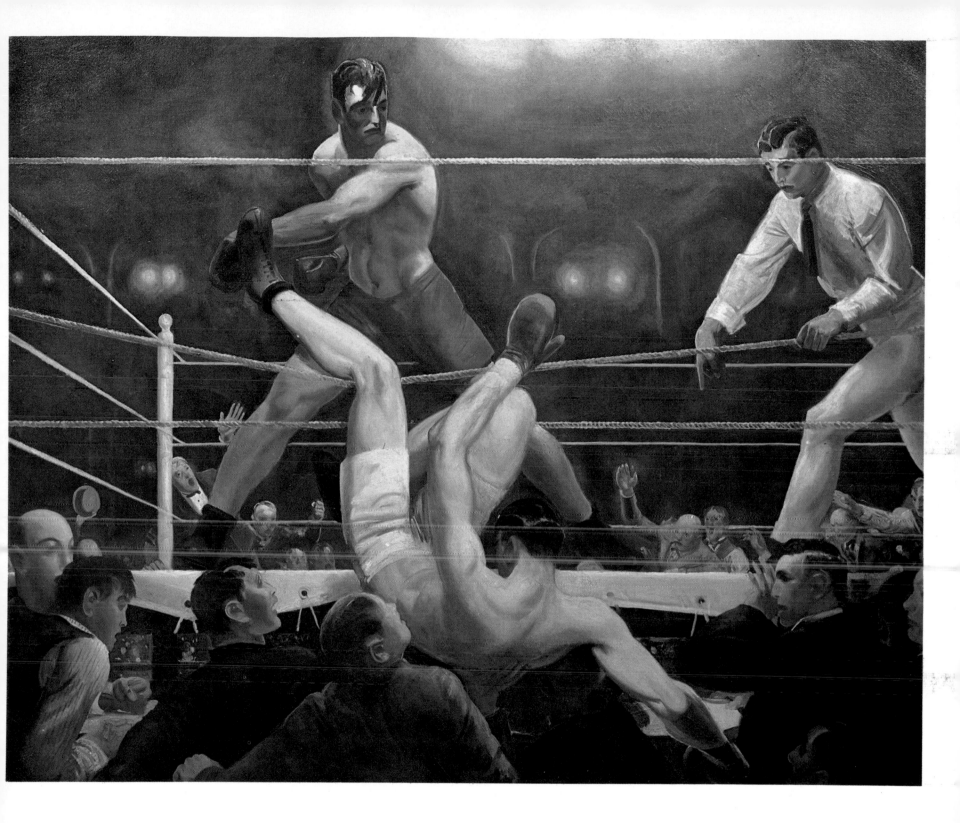

Plate 63

LADY JEAN

1924
72" x 36"
Oil on Canvas
Yale University Art Gallery, New Haven, Connecticut

Lady Jean looks as demure as could be, but if some of the stories are true she was a bit of a mischief-maker on the side. Posing can be appallingly boring for a kid, and Jean did not always enjoy it. Bellows idolized and idealized his daughters, and they reciprocated. Stephen Clark, who left part of his collection to Yale, bought both this portrait and the *Katherine Rosen.* He was a good picker. This picture was painted at the same time as *Dempsey and Firpo,* from which it differs in treatment as well as subject matter. This one was a triumphant success; *Dempsey and Firpo* is a flawed triumph. As you can see, Jean was quite an actress as a little girl. Later, she played summer stock in Massachusetts, and was in a USO touring group overseas during World War II. She was also in several New York plays, and appeared with Helen Hayes.

Plate 64
THE PICNIC
1924
30⅛" x 44¼"
Peabody Institute, Baltimore, Maryland
Courtesy of the Baltimore Museum of Art

Daniel Catton Rich, the long-term director of the Art Institute of Chicago, asked: "How could the man who painted 'Both Members of This Club' turn out mannered pictures like 'The Picnic'?" He answers his own question: "Bellows was a born painter. . . . If he attempted to *design* his works according to new formulas and started to heighten his palette artificially he produced a stylized and often garish result. . . . For the truth is Bellows was not an intellectual painter. He was a highly intelligent one and brilliantly gifted in the visual and manual aspect. Theories and recipes defeated him." Certainly those folded hills are something he worked up, not something he saw. *The Picnic,* painted in 1924, lies at the outer edge of the artist's career. Bellows was very much interested in the craft of painting, and he was strongly affected by writers such as Denman Ross, who made a detailed study of sixty different color palettes. Some of the pictures Bellows painted under Ross' shadow were limited to a few colors, others were painted with the rainbow. It is difficult to exaggerate the colorfulness of the American countryside, and in *The Picnic* the new Maratta colors worked to their best advantages. At other times the result is close to disaster. In compositional matters he deferred to Jay Hambidge, apostle of "Dynamic Symmetry," which Bellows regarded as "probably more valuable than the study of anatomy."

Edited by Jennifer Place
Designed by James Craig and Robert Fillie
Composed in 11 point Garamond by University Graphics, Inc.
Printed and bound in Japan by Toppan Printing Company Ltd.